2000

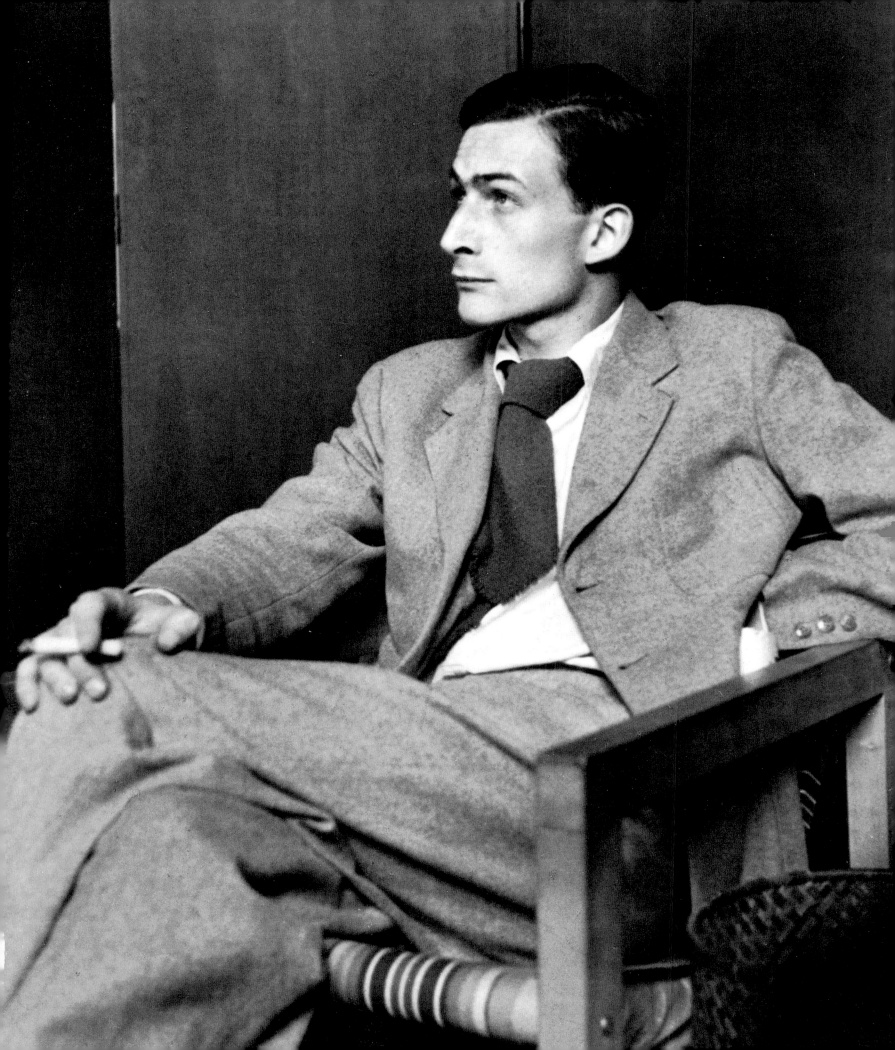

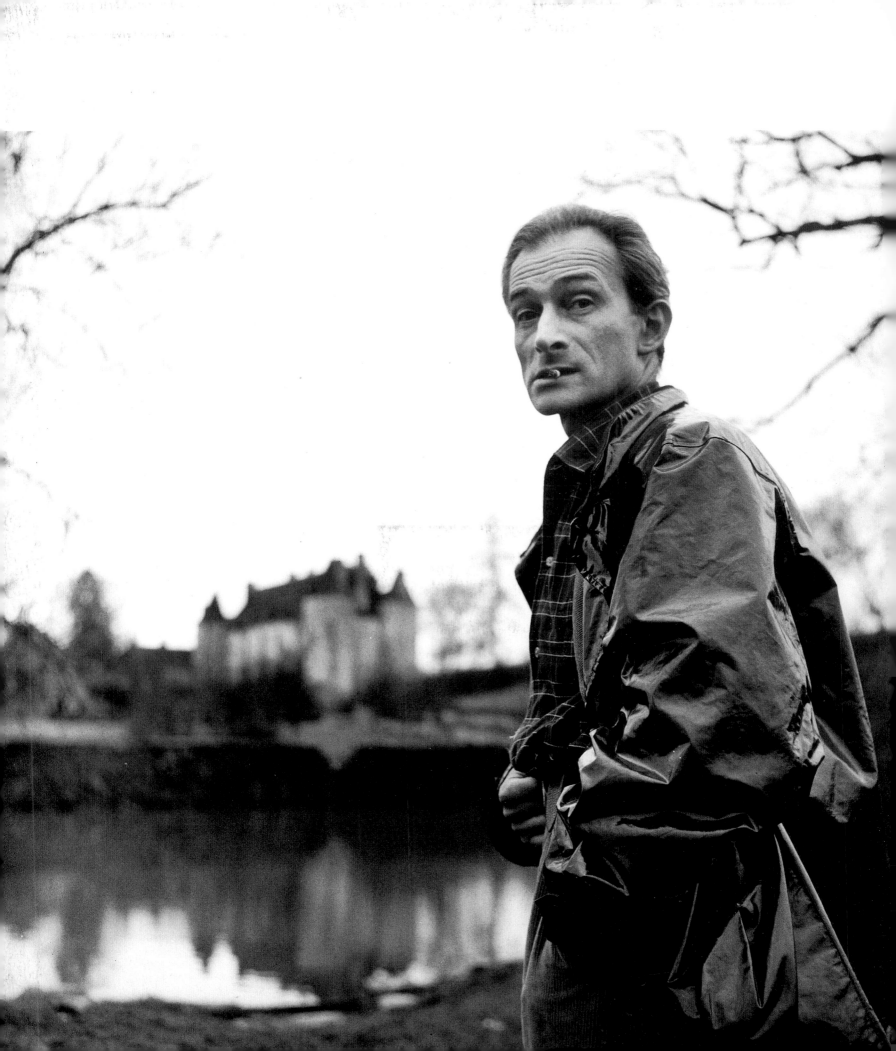

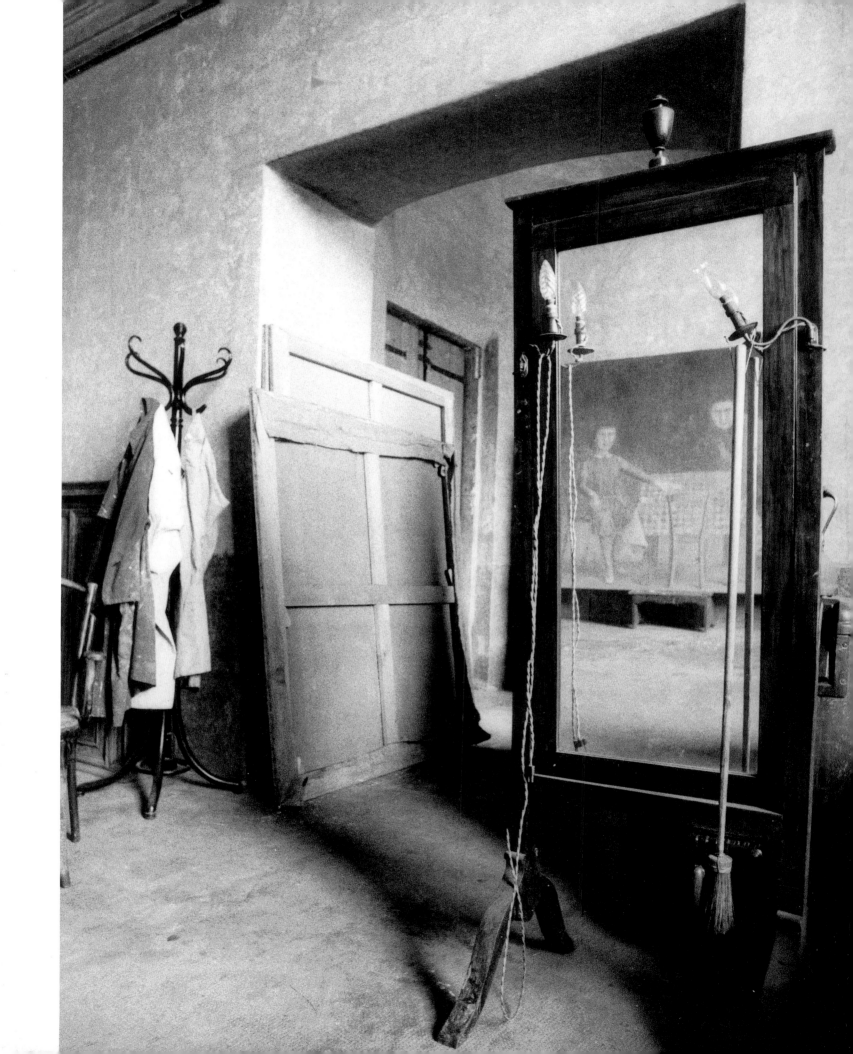

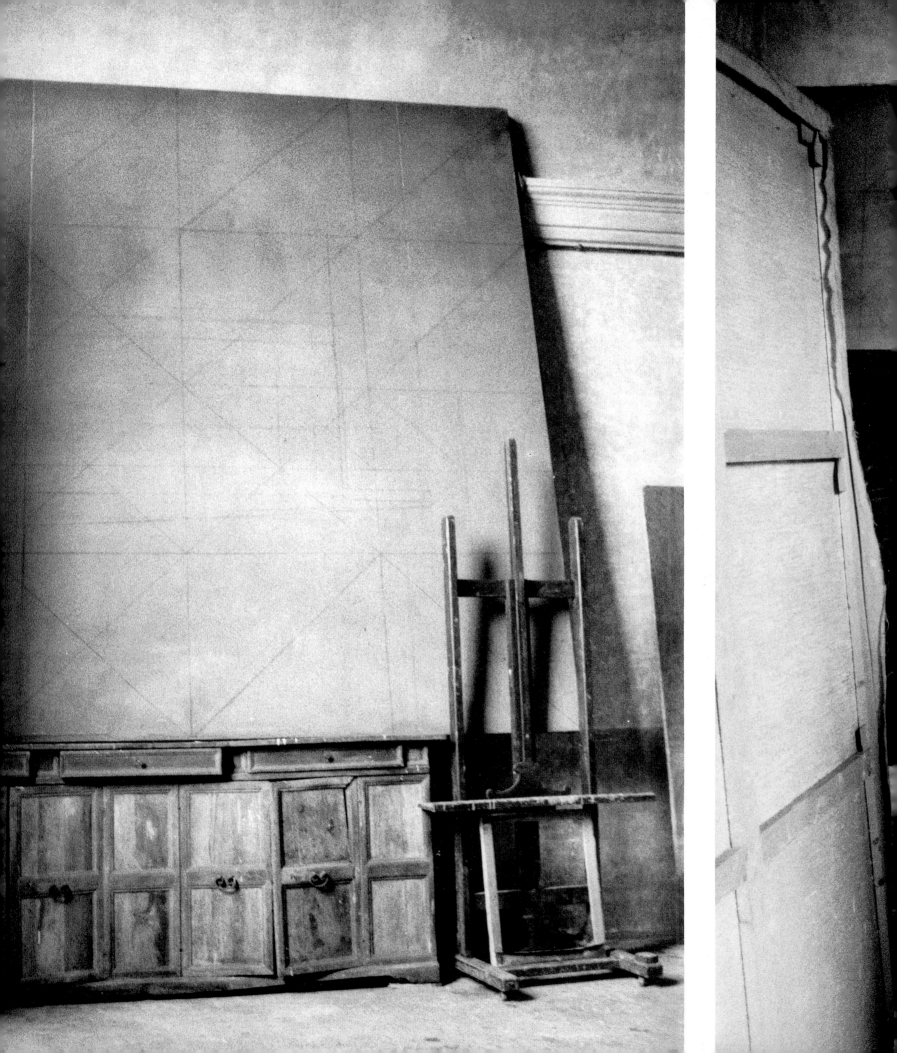

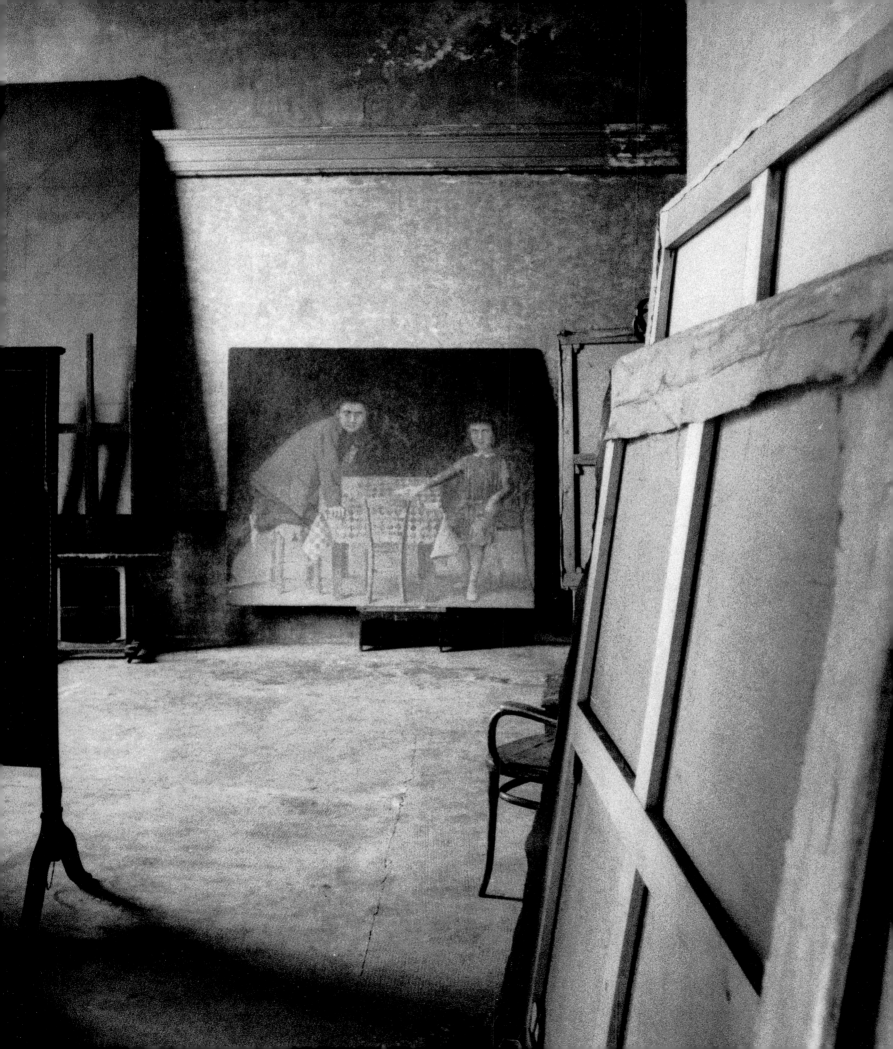

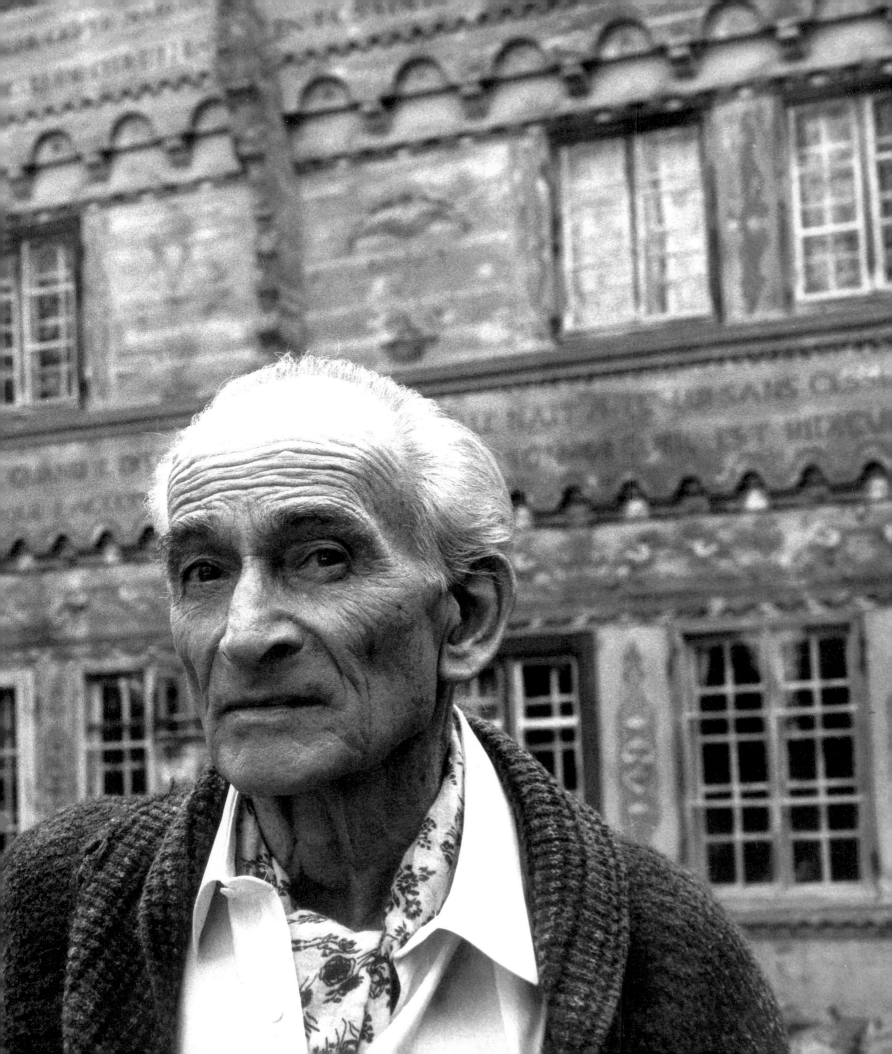

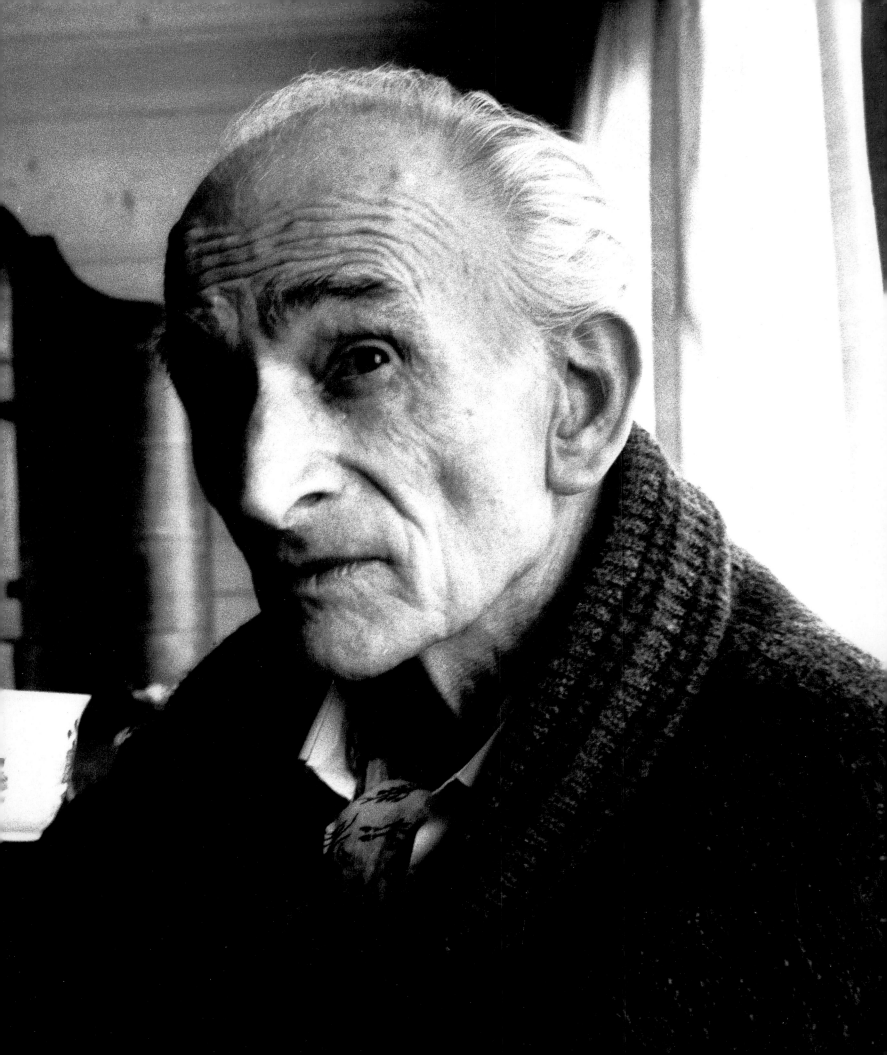

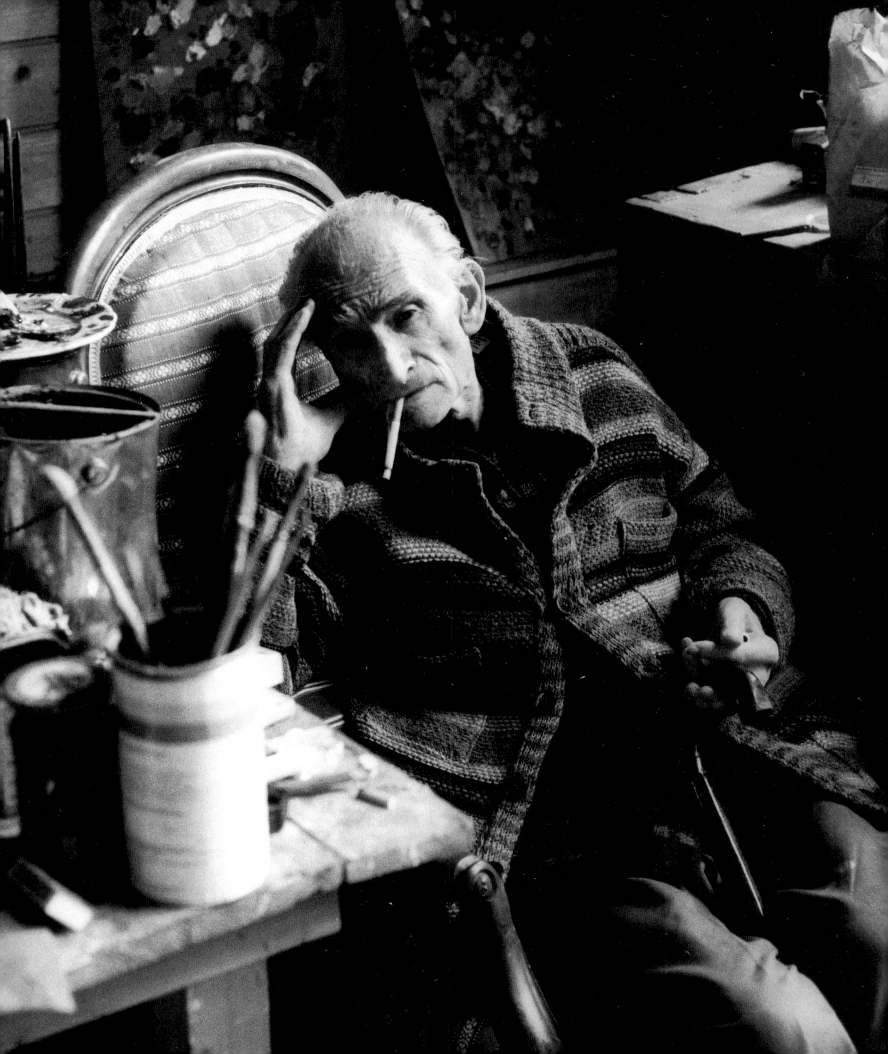

BALTHUS

Stanislas Klossowski de Rola

BALTHUS

HARRY N. ABRAMS, INC., PUBLISHERS

Acknowledgments

The author and the publishers would like to express their gratitude to the late Pierre Matisse, the late Henriette Gomes and to His Grace the Duke of Beaufort for their help in gathering photographic material for the first version of this book. We would also like to thank the private individuals who have allowed their works to be photographed for this book and the institutions that have supplied us with transparencies.

For this updated and considerably enlarged edition we are indebted first and foremost to Countess Setsuko Klossowska de Rola, who provided the bulk of the additional material. We would also like to thank Martin Summers and The Lefevre Gallery, Madame Virginie Monnier and Madame Bernard Hahnloser for their generous and invaluable contributions.

Library of Congress Cataloging-in-Publication Data

Klossowski de Rola, Stanislas.
 Balthus / Stanislas Klossowski de Rola.
 p. cm.
 ISBN 0–8109–3134–6 (clothbound)
 1. Balthus, 1908– —Catalogs. I Title.
 ND553.B23A4 1996
 759.4—dc20 96–14108

Printed and bound in Singapore

Contents

Introduction

L'artiste reproche tout d'abord à la critique de ne pouvoir rien enseigner au bourgeois, qui ne veut ni peindre ni rimer, — ni à l'art, puisque c'est de ses entrailles que la critique est sortie. Et pourtant que d'artistes de ce temps-ci doivent à elle seule leur pauvre renommée! C'est peut-être là le vrai reproche à lui faire.

Charles Baudelaire

In 1983, while I was writing the original introduction to the present work, my father's staunch conviction that biographical details about an artist were not helpful to the study of his art remained paramount. At the time Balthus was extremely reluctant to speak to reporters, he had refused every overture to appear on television and had not allowed anyone to photograph him in years.

In recent years, however, he has given numerous interviews, and has been the subject of several television documentaries. To some extent he has also overcome his long-standing reluctance to be photographed, having sat for various photographers, including his old friend Henri Cartier-Bresson. Nevertheless, he still expresses considerable disappointment with virtually everything written about him, which is all too often characterized by a combination of misunderstanding and sheer nonsense.

Thus, despite the apparent paradox of some arbitrary concessions to the demands of world-wide fame, Balthus remains as convinced as ever that his pictures should be seen, not read about, or read into. That, in essence, is why the English art critic John Russell, after pressing Balthus for biographical details while preparing his text for the 1968 Balthus retrospective at the Tate Gallery in London, received the following telegram:

NO BIOGRAPHICAL DETAILS. BEGIN: BALTHUS
IS A PAINTER OF WHOM NOTHING IS KNOWN.
NOW LET US LOOK AT THE PICTURES.
REGARDS. B.

Needless to say, art critics and art historians generally feel otherwise. They dearly love to dissect every available shred of biographical information in a misguided search

for clues explaining his work. They are also fond of displaying their knowledge of art by tracing – to often outlandish sources – the heraldic lineage of a composition. In a few extreme cases they have been known to speculate recklessly on the situations, or predicaments, in which they believe the subjects of the paintings to be. Such unbridled flights of fancy are not only laughable, they contribute very little to the true appreciation of art. This, the philosopher A. K. Coomaraswamy warns us, 'must not be confused with a psycho-analysis of our likes and dislikes dignified by the name of "aesthetic reactions"… The study of art, if it is to have any cultural value, will demand two far more difficult operations than this, in the first place an understanding and acceptance of the whole point of view from which the necessity for the work arose, and in the second place a bringing to life in ourselves of the form in which the artist conceived the work and by which he judged it. The student of art must be able to elevate his own levels of reference from those of observation to that of the vision of ideal forms. He must rather love than be curious about the subject of his study.'

A possible way to avoid the depressing misunderstandings that seem, almost invariably, to prevail among even those who claim to be Balthus's greatest admirers might be for the lover of his art to try to contemplate the paintings. By 'contemplation' I mean the elevation from mere perusal and observation to vision, from the empirical to the ideal – a state wherein the act of seeing, the seen and the seer become one. Should one be able to overcome the superficial handicap of one's 'aesthetic reactions' (described by the anthropologist R. Firth as 'an excrescence upon a genuine interest in art which seems peculiar to civilized peoples'), one might then be able to penetrate the deeper meaning of the work and thus truly to judge it. Any other way is, I fear, doomed to failure, for Balthus celebrates a mysterious tradition whose secret and

sacred tenets he is constantly in the process of rediscovering. From early childhood his path seems to have been determined by fate in that very direction. In a letter written in 1922 Rainer Maria Rilke marvelled at 'this boy, so strangely orientated towards the East… When we went to see him at Beatenberg in September, he was just painting Chinese lanterns, with a flair for the oriental world of form that is amazing. Then we read the little Book of Tea: one can't imagine where he gets all his assured knowledge of Chinese Imperial and artistic dynasties.'

Nevertheless, his artistic progress was far from easy. He has often deplored the loss of the basic craft of painting, whose skills, techniques and trade secrets in past centuries could have been learnt in a master's studio. In his relentless quest of this elusive mastery, which has often reduced him to despair, Balthus laments having had to teach himself everything by trial and error. He has compared the task imposed upon him by his inner yearning to that of trying to write in an unknown language without knowing its vocabulary or grammar. As a result he is continually attempting to recapture the forgotten art of painting and to reinvent its language.

The stages of his artistic evolution led him from his faltering first steps to what he perceived as the necessity of trying at all costs to represent 'reality' in his work. He is quick to point out that the means he has employed in his search for greater realism were in his earlier works more akin to drawing than to painting. Then, as his vision evolved, seeds of doubt began to sprout, and the painter felt the very nature of the seen escaping him more and more. Such an exacting tribute to ripening vision and experience had to be paid before the fruits of his efforts in painting could be crowned by the kind of magical transmutation that Braque calls '*le fait pictural*' (the pictorial fact).

In his most recent works (which have taken longer and longer to complete), Balthus builds layer upon layer of contrasting hues and extraordinary textures, and thereby achieves a strange hieratic intensity of incredible subtlety. Despite his advancing years and recent bouts with ill health, he keeps on working, propelled toward an unknown ideal, equating the act of painting to that of praying. In the words of the *Bhagavad Gîta*, 'the man devoted to his own vocation finds perfection... That man, whose prayer and praise of God are in the doing of his own work perfects himself.' And in the *Asclepius* of Hermes Trismegistus it is said that 'if a man takes upon him in all its fullness the proper office of his own vocation [*curam propriam diligentiae suae*], it is brought about that both he and the world are the means of right order to one another. For since the world is God's handiwork, he who maintains and heightens its beauty by his tendences [*diligentia*] is co-operating with the will of God... What shall be his reward? That when we are retired from office [*emeritos*] God will restore us to the nature of our better part which is divine.'

I must stress once again that the fabled theme of the languid adolescent girl, which Balthus has treated repeatedly, has nothing whatsoever to do with sexual obsession, except perhaps in the eye of the beholder. These girls are in fact untouchable archetypes of purity belonging to a higher realm. Their very youth is the emblem of an ageless body of glory, as adolescence (from the Latin *adolescere*, to grow toward) aptly symbolizes that heavenward state of growth to which Plato refers in the *Timaeus*.

There is one flagrant exception constituted by the deliberately provocative subject matter of *The Guitar Lesson* (1934), a superb painting that was kept in a separate room and only shown to certain people at the Galerie Pierre Exhibition in Paris. Despite my desire to include it in the present work, my father has refused to endorse its further

dissemination. Although it has been reproduced several times, it has never been done with his consent. It is indeed most unfortunate that the sacred nature of eroticism is all too often associated with pornography and libidinousness, a deplorable confusion that obscures the real meaning of such esoteric works ultimately relating to the divine cosmic mysteries of love and desire.

I am well aware of the fact that those learned pundits who rejoice in their own opinionated fantasies about Balthus and the meaning of his art will again dismiss my words and stick to their own guns. Those eminent members of the self-styled international cultural élite view art essentially as the self-revelation or self-expression of the artist. They appear far more concerned with styles, dates and influences than with the artist's true intention, which they are wont to disregard if it doesn't fit their own theories. By substituting the study of the artist himself for the study of his art, they often claim in a pseudo-psychological fashion to explain everything. Although the characteristic feature of their discourse is meaninglessness, 'these leaders of the blind', as Coomaraswamy calls them, 'are gladly followed by a majority of modern artists, who are naturally flattered by the importance attached to personal genius'. Balthus, by contrast, hardly enjoys the games of fame, as he aspires instead to the anonymous perfection of a man liberated from the burden of his ego. In that context, therefore, he considers both his individuality and his work a means, not an end.

PLATES

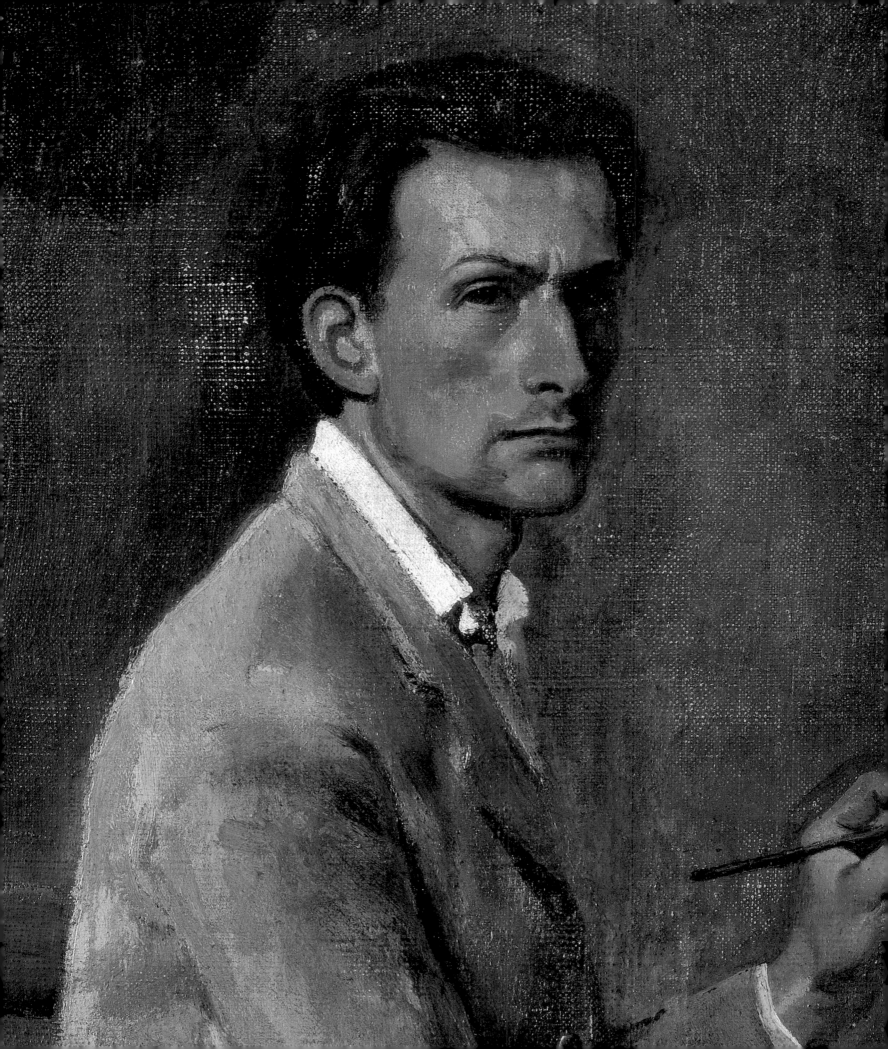

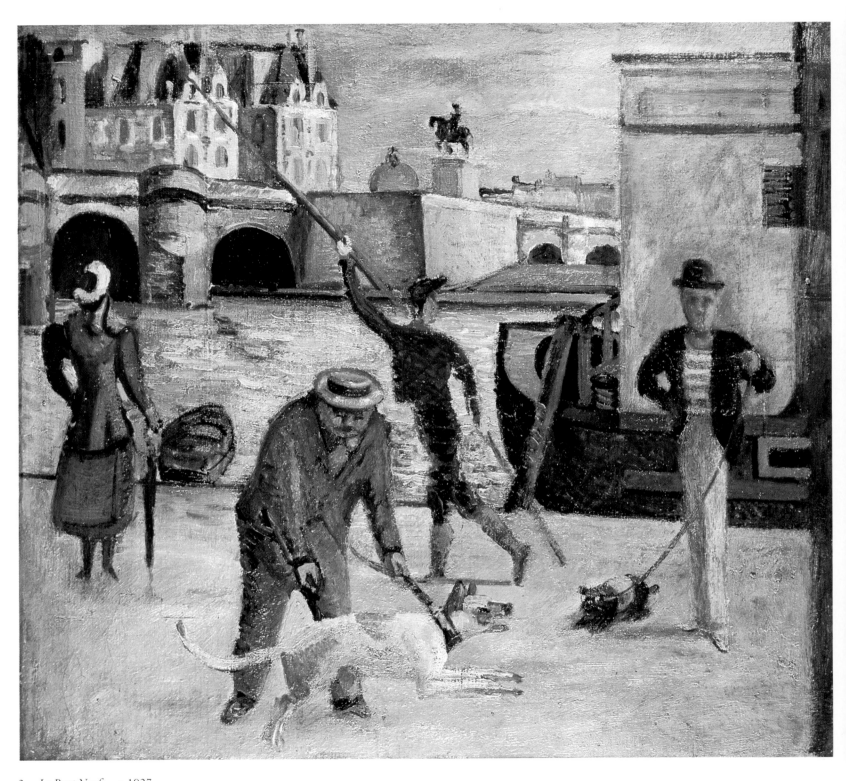

2　*Le Pont Neuf*　c. 1927

◁ 1　*Autoportrait*　(detail)　1940

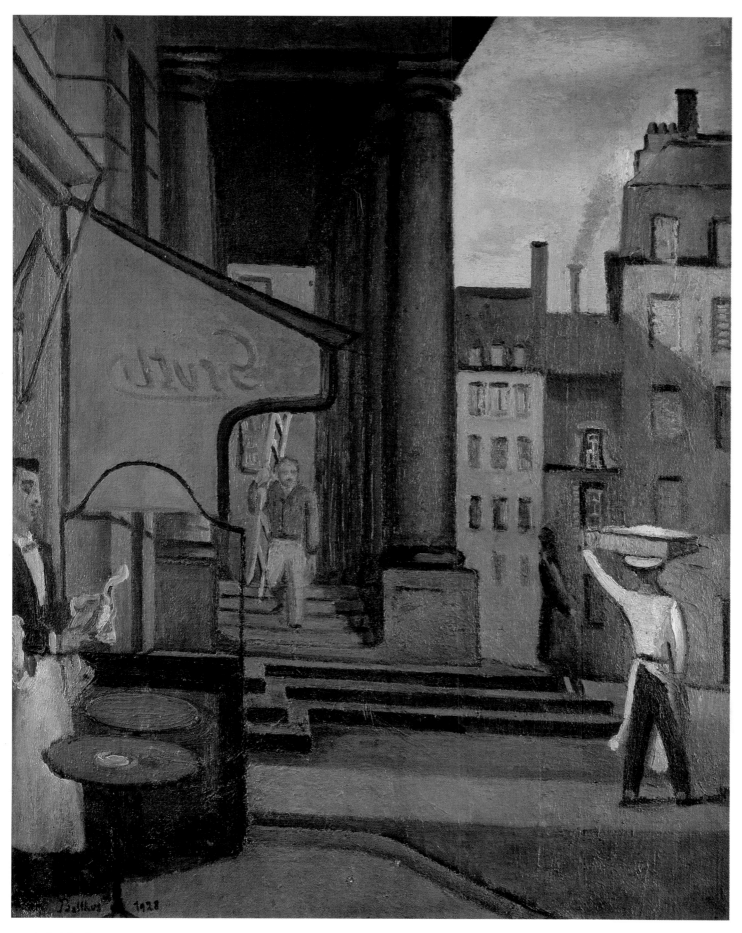

3 *Café de l'Odéon* 1928

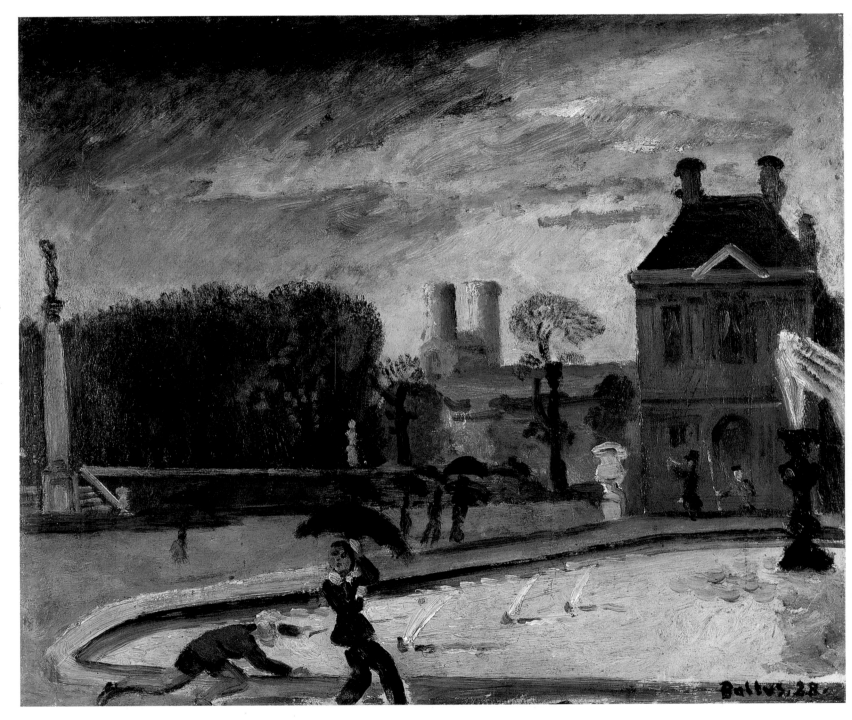

4 *Jardin du Luxembourg* 1928

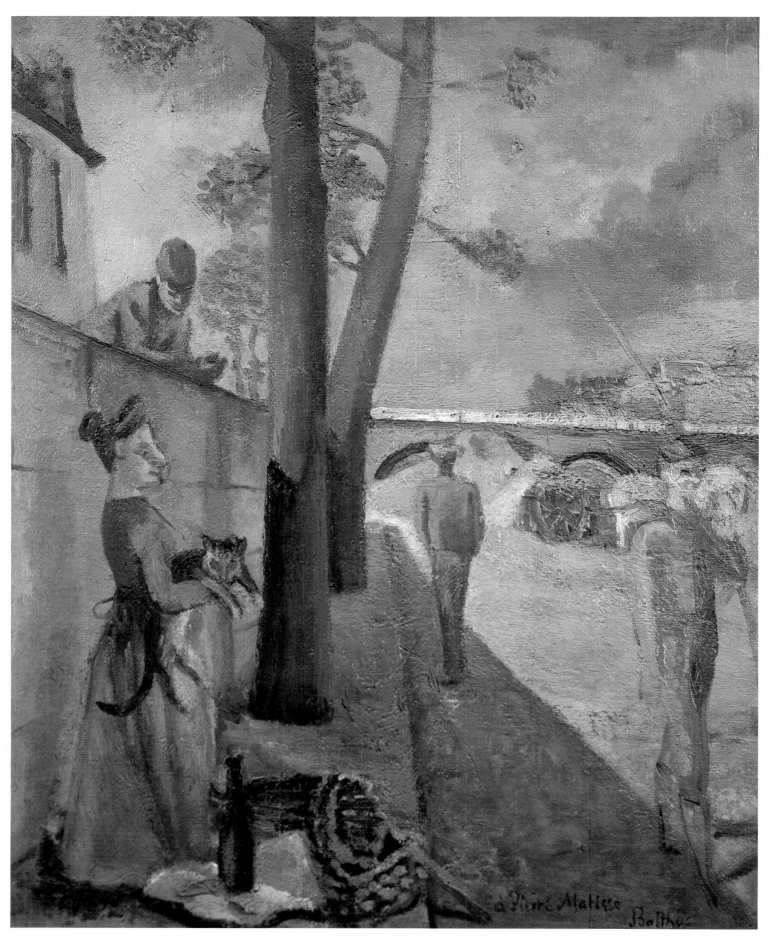

5 *Les quais* 1929

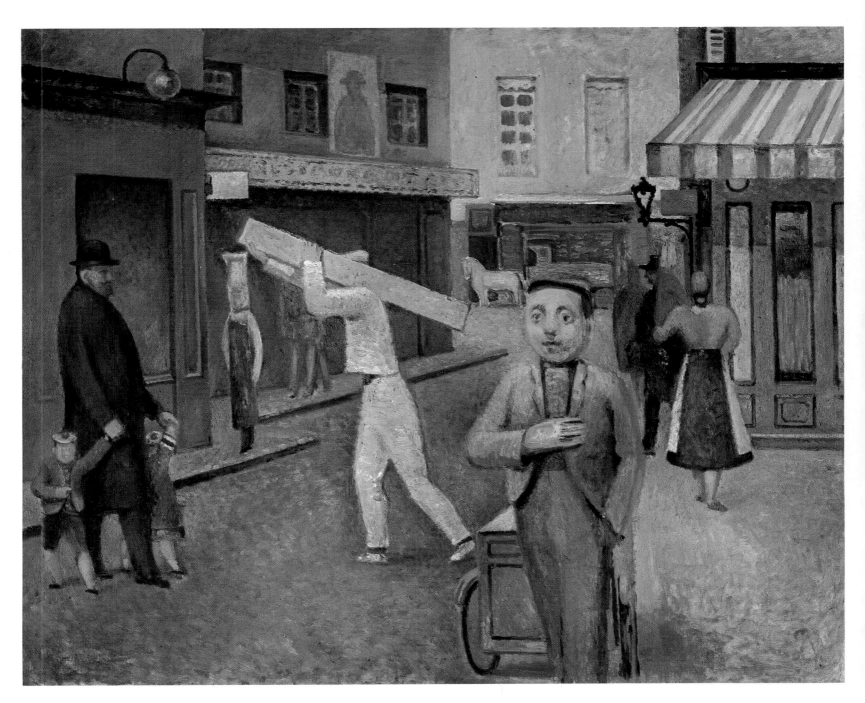

6 *La rue* 1929

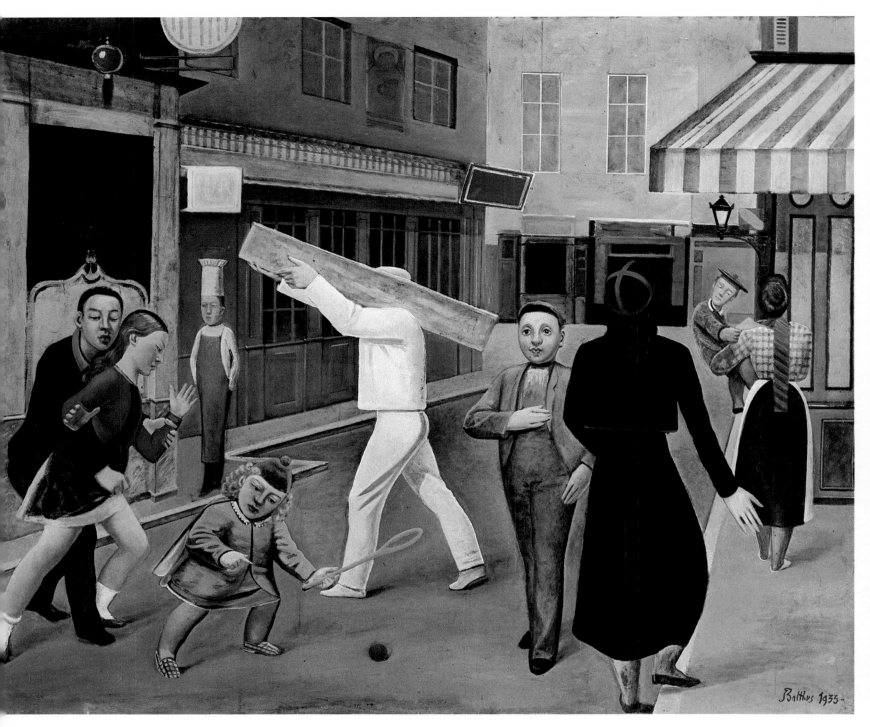

7–9 *La rue* 1933–35

8, 9 >

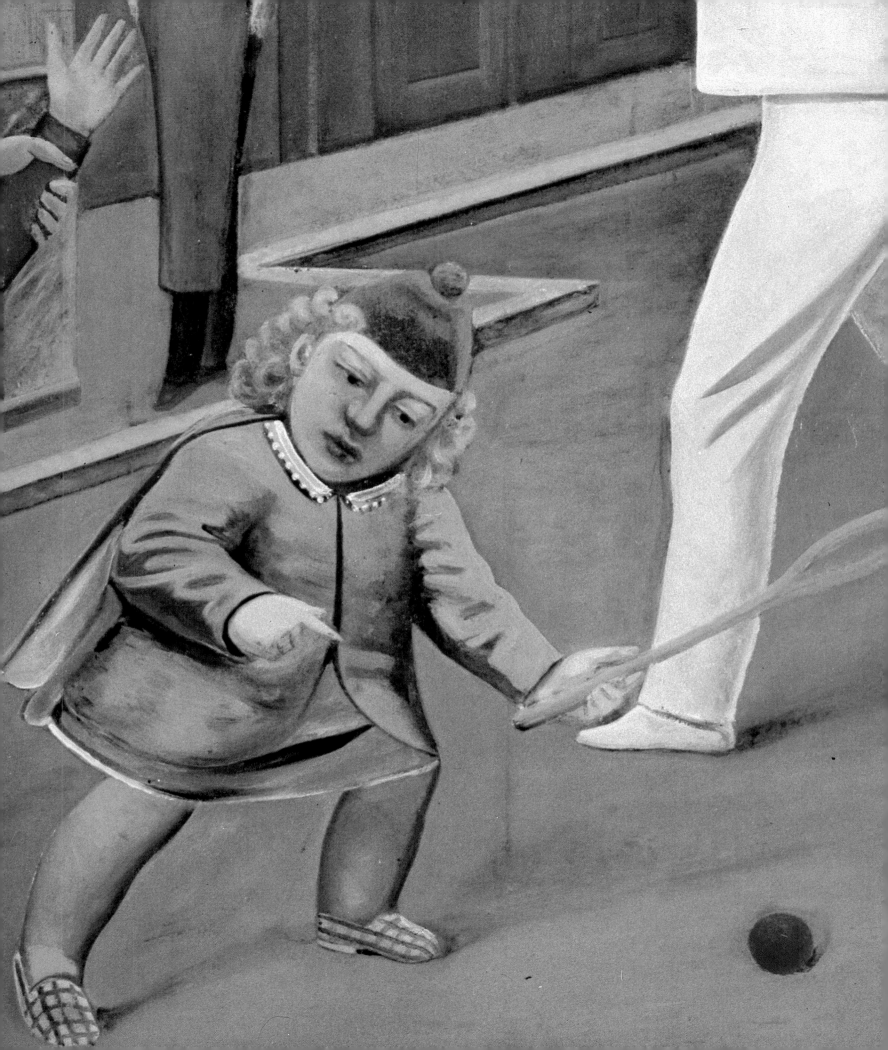

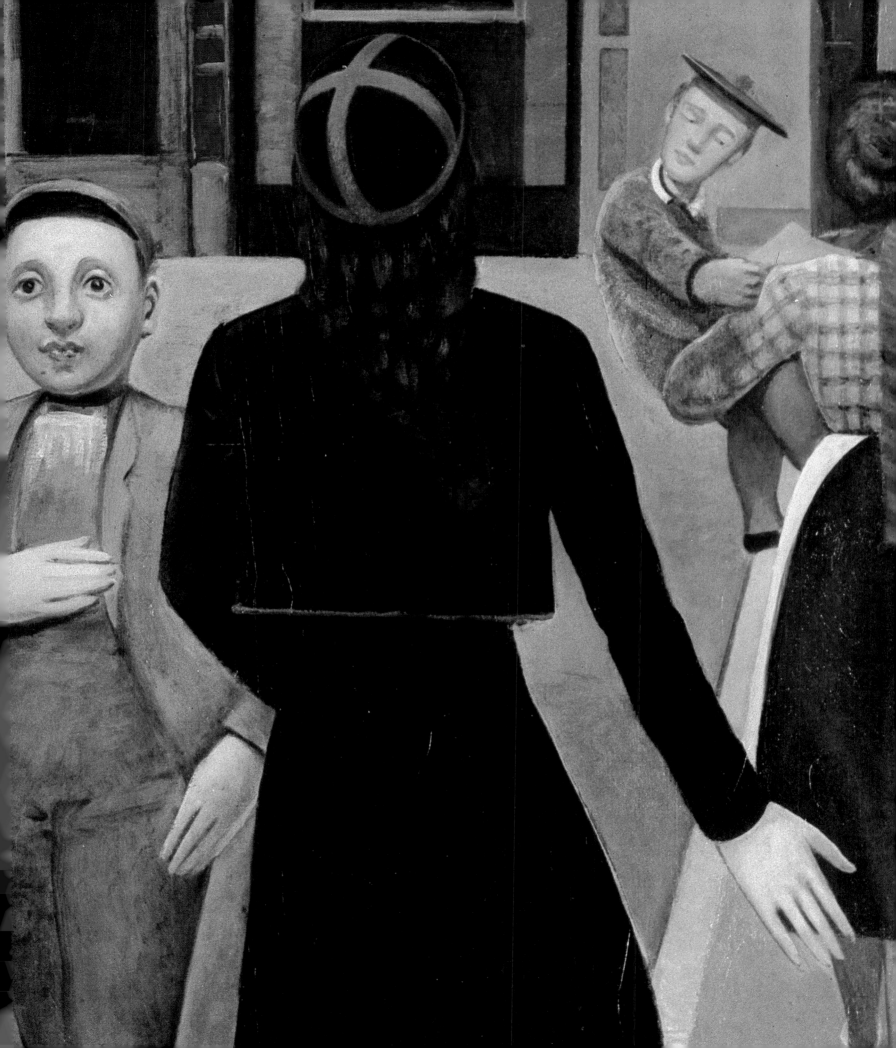

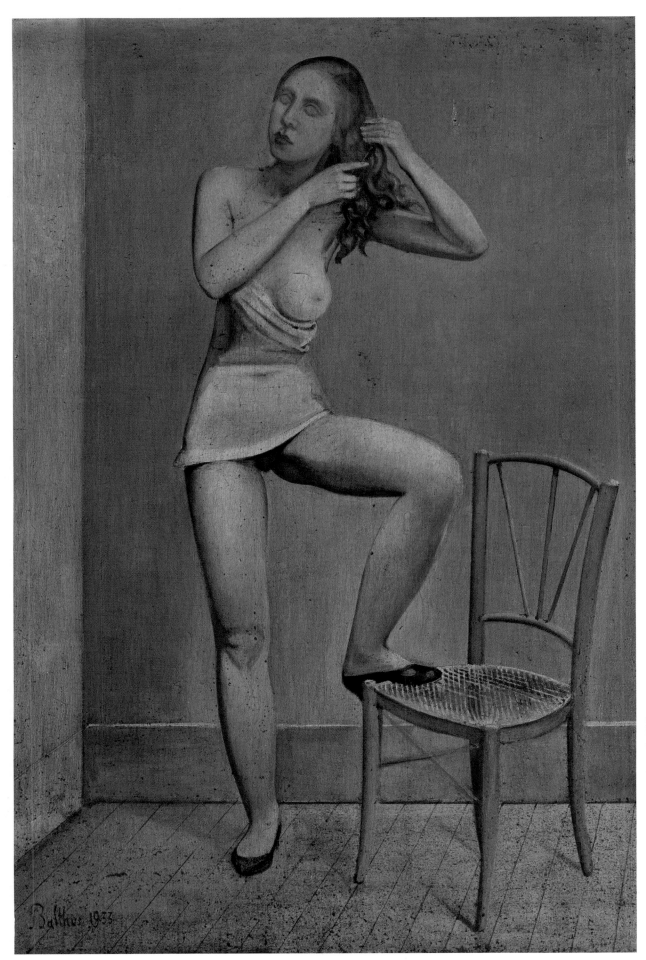

10 *Alice* 1933

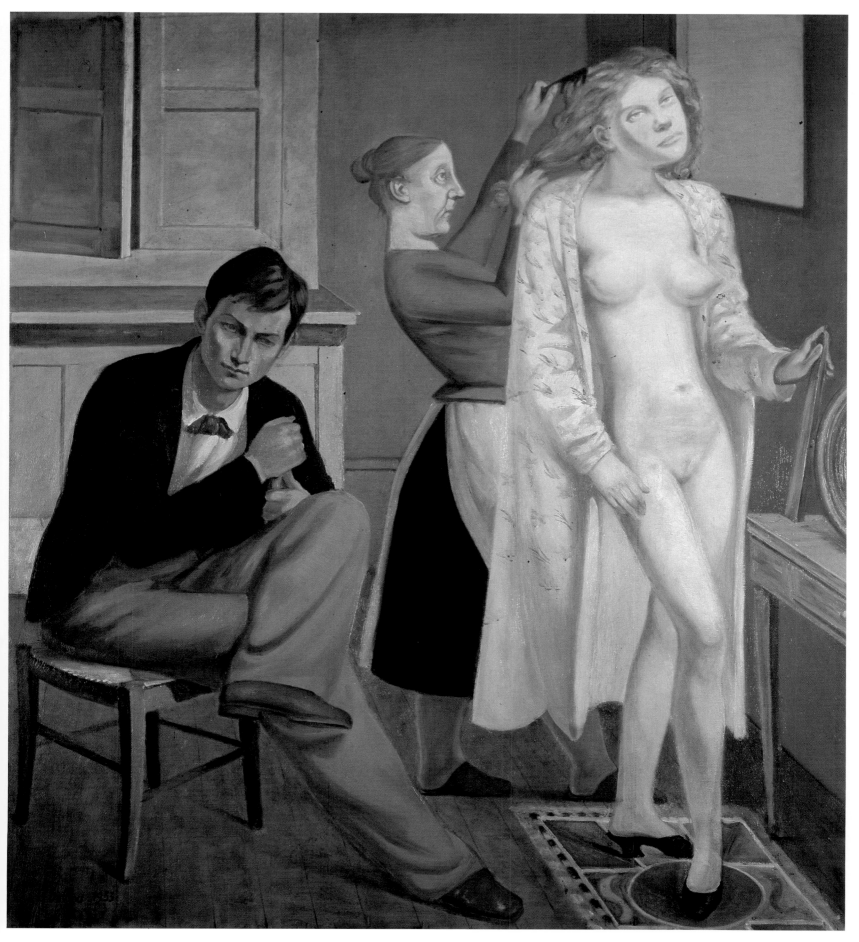

11 *La toilette de Cathie* 1933

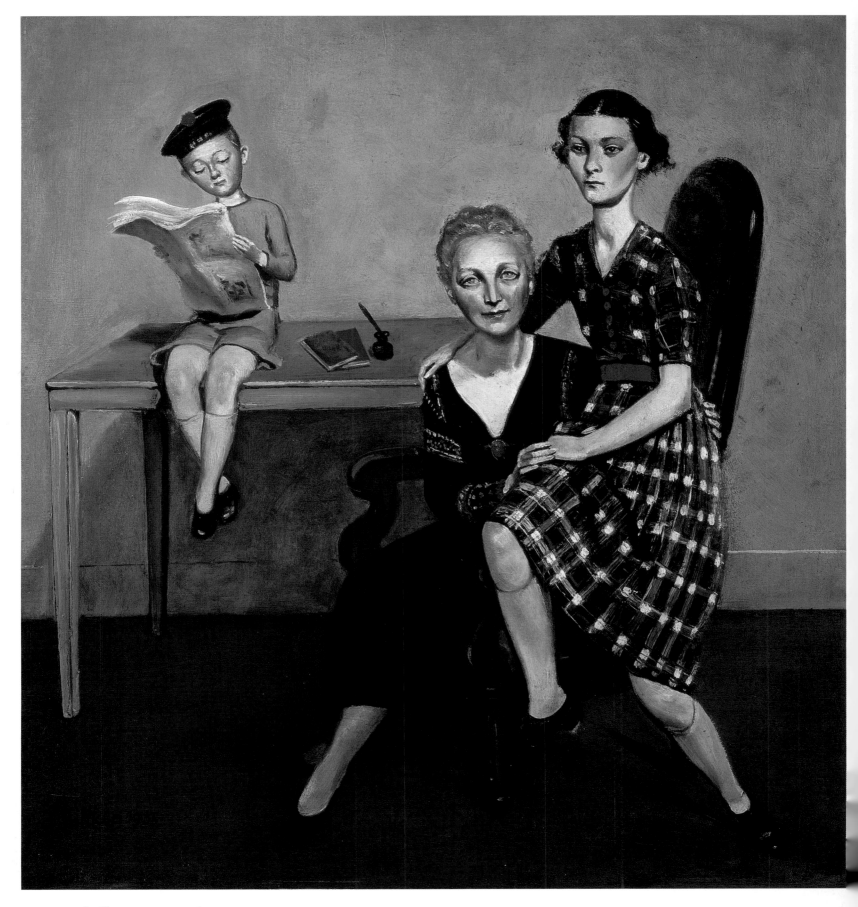

12, 13 *La famille Mouron-Cassandre* 1935

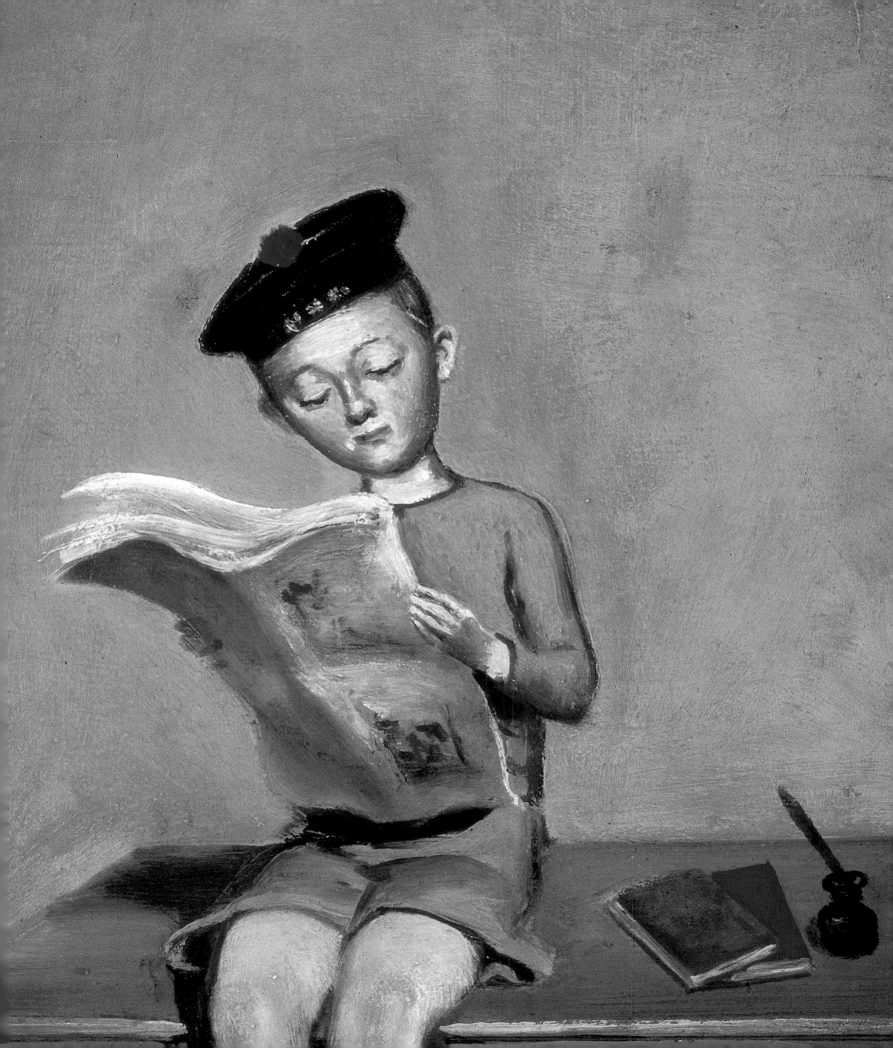

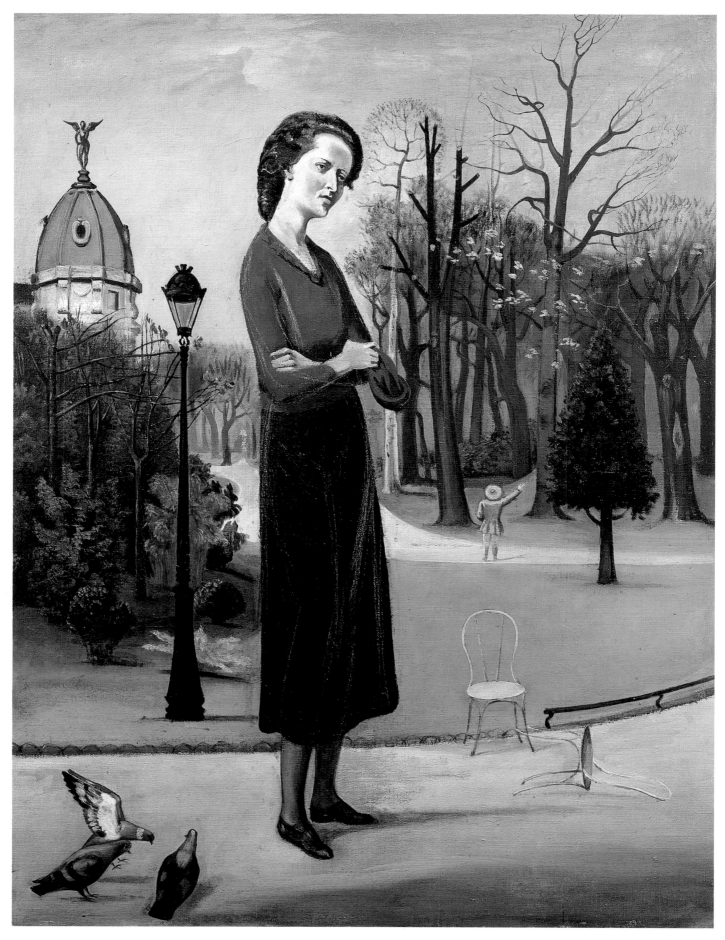

14　*Lelia Caetani*　1935

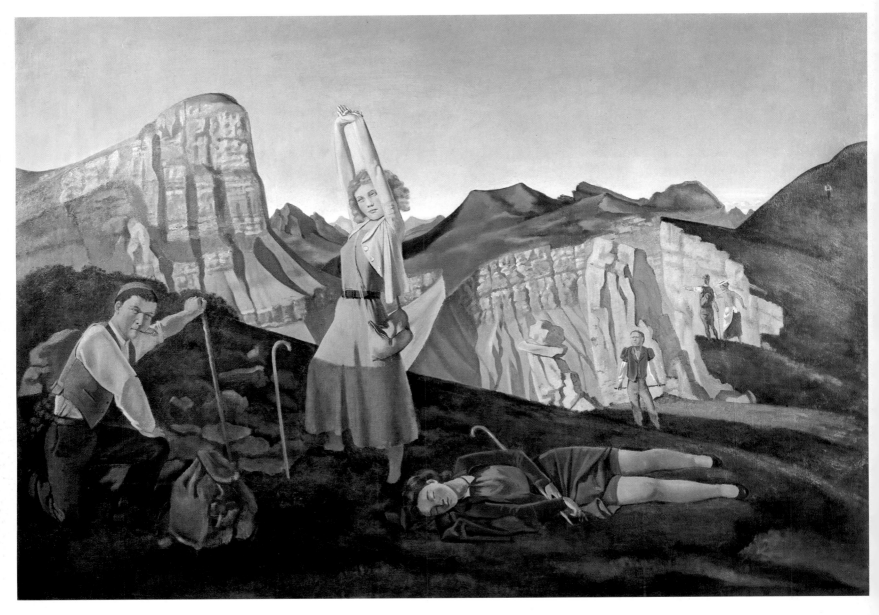

15, 16 *La montagne* 1935–37

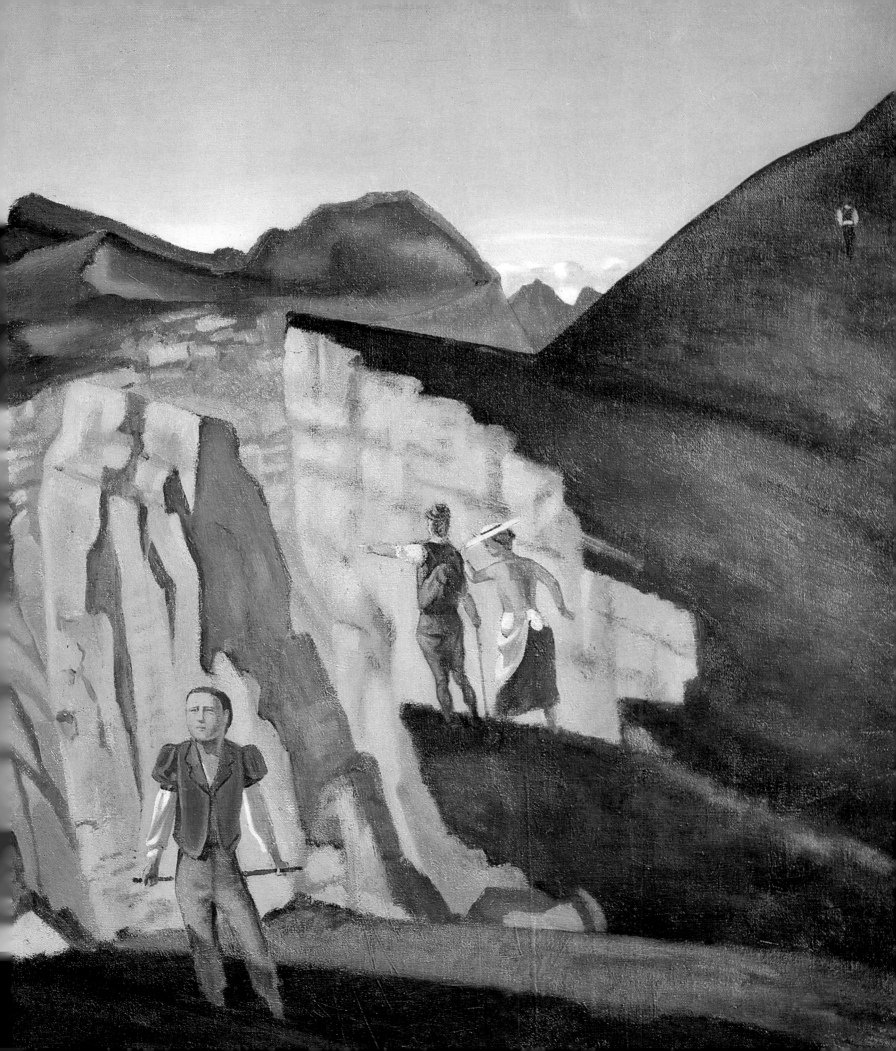

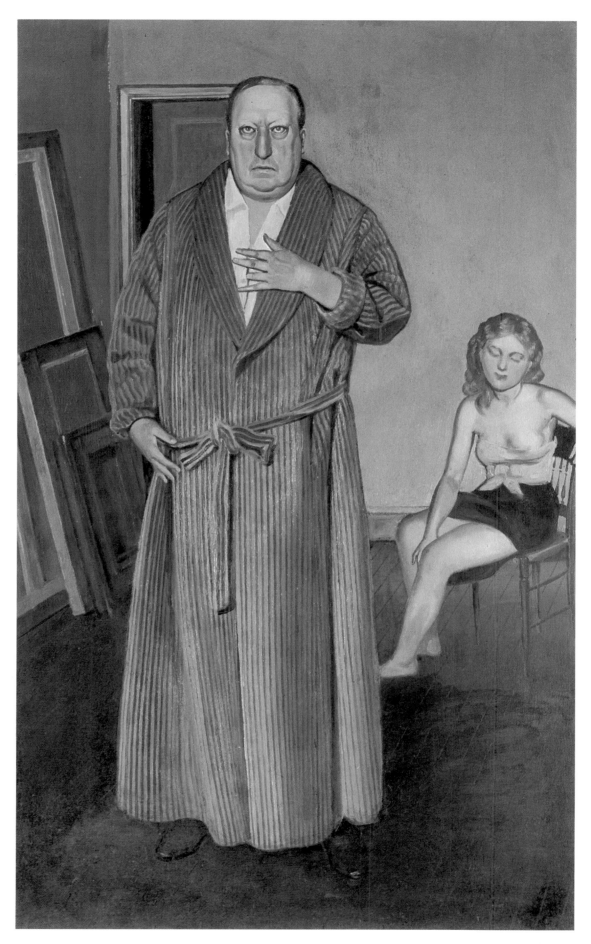

17 *André Derain* 1936

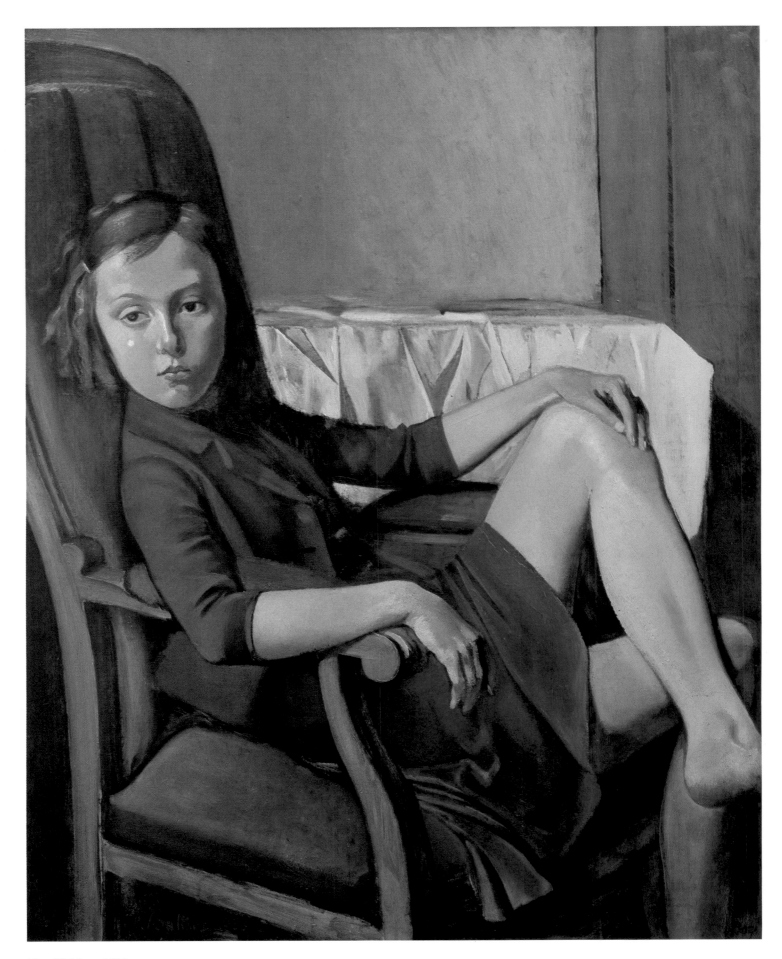

18 *Thérèse* 1938

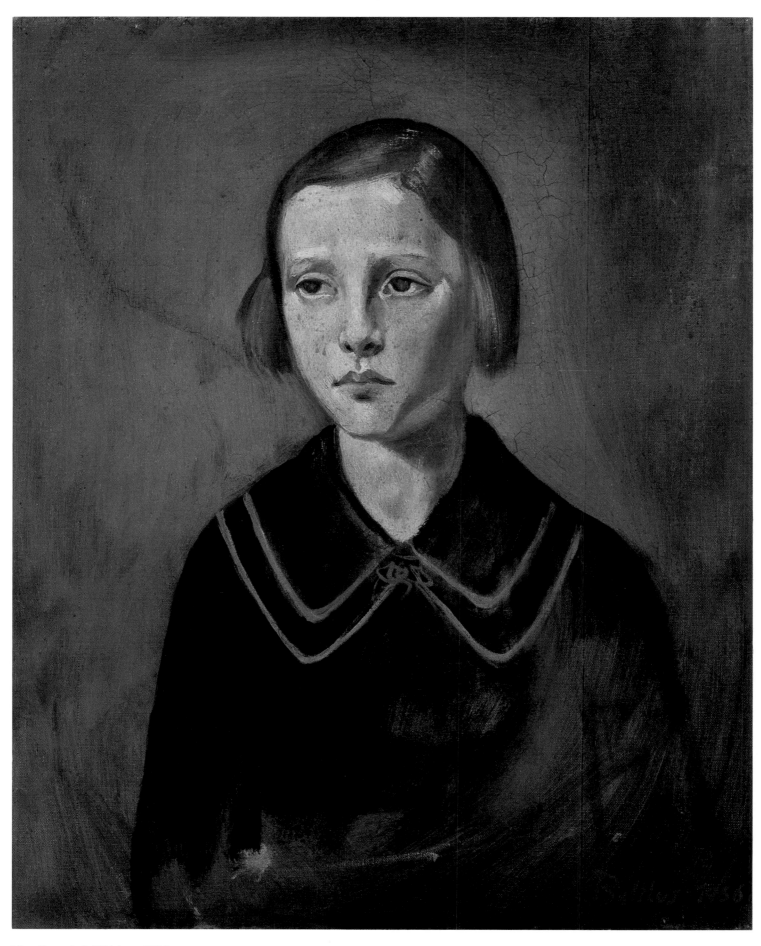

19 *Portrait de Thérèse* 1936

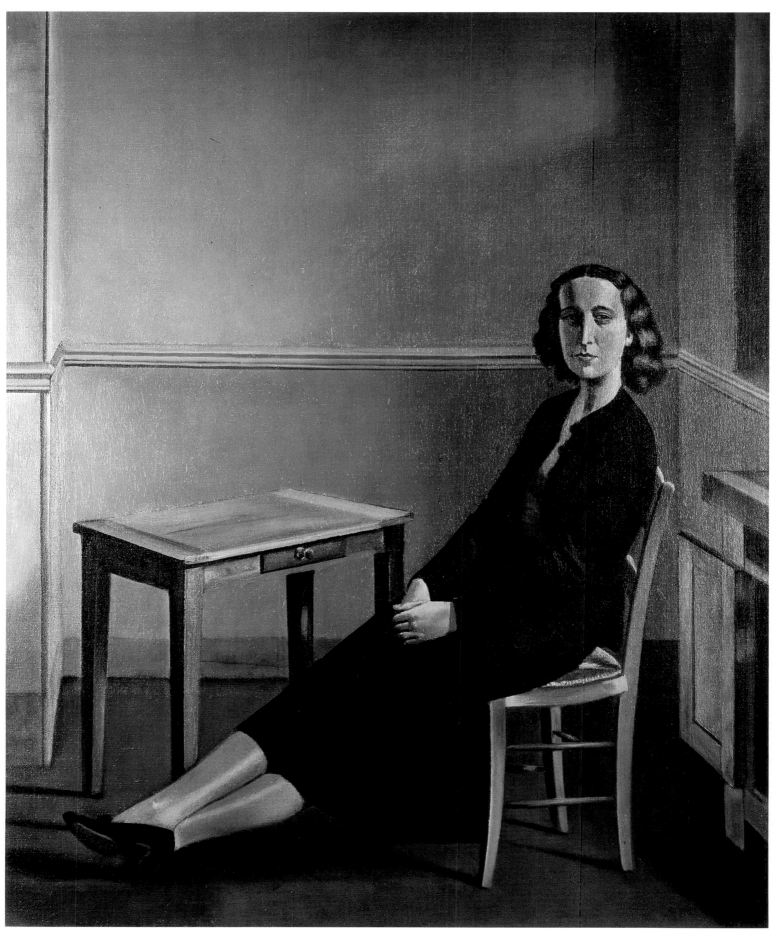

20 *Portrait de la Vicomtesse de Noailles* 1936

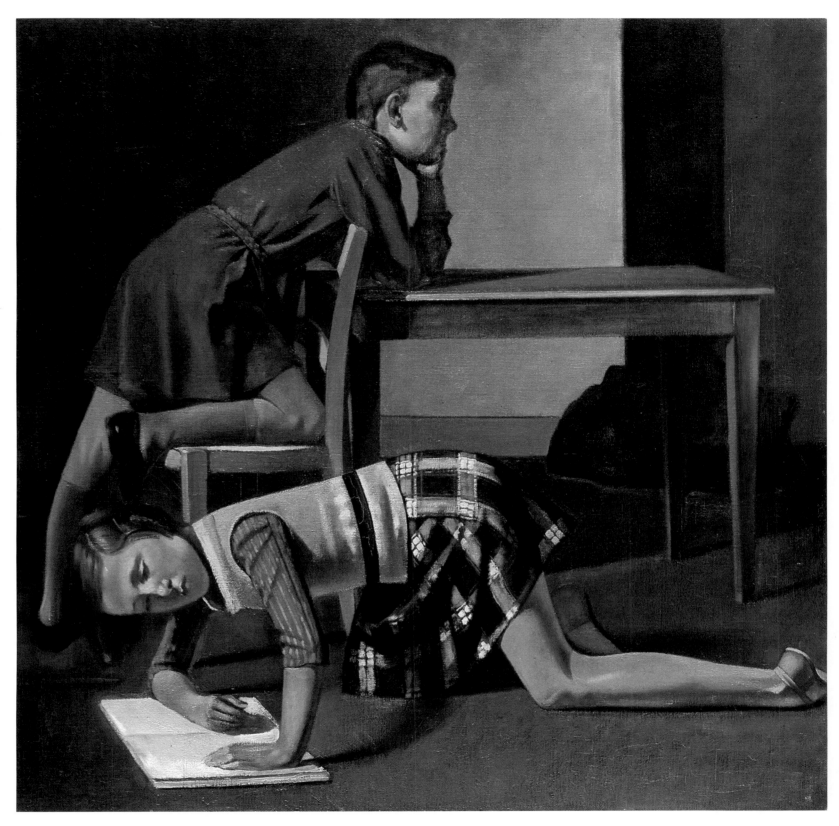

21 *Les enfants* 1937

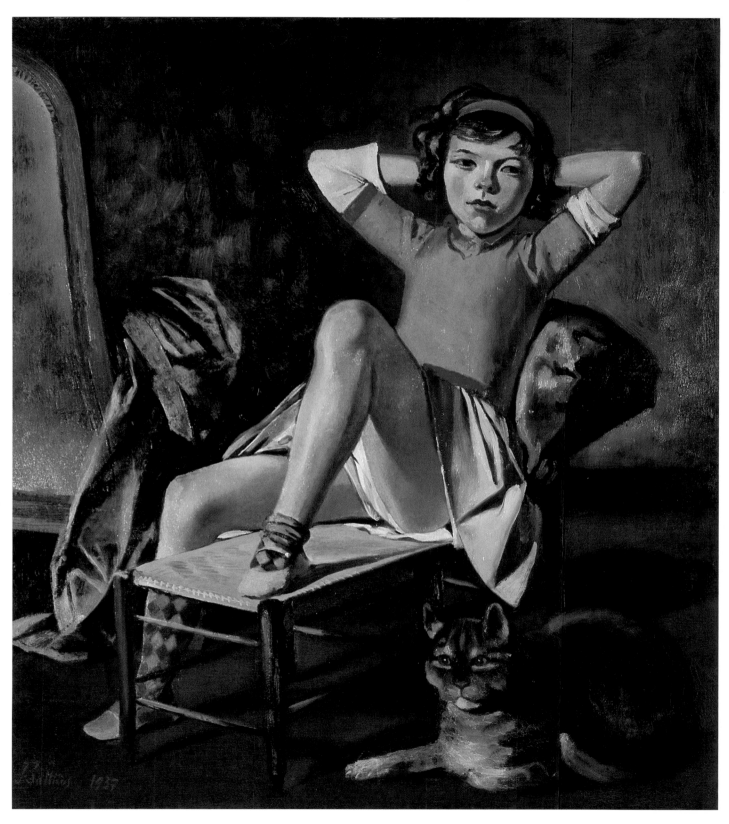

22 *Jeune fille au chat* 1937

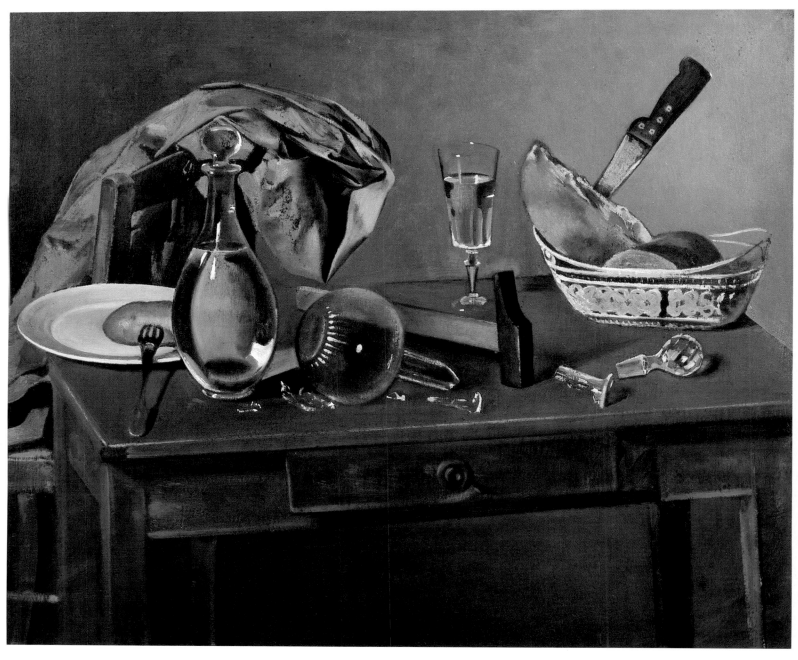

23 *Nature morte* 1937

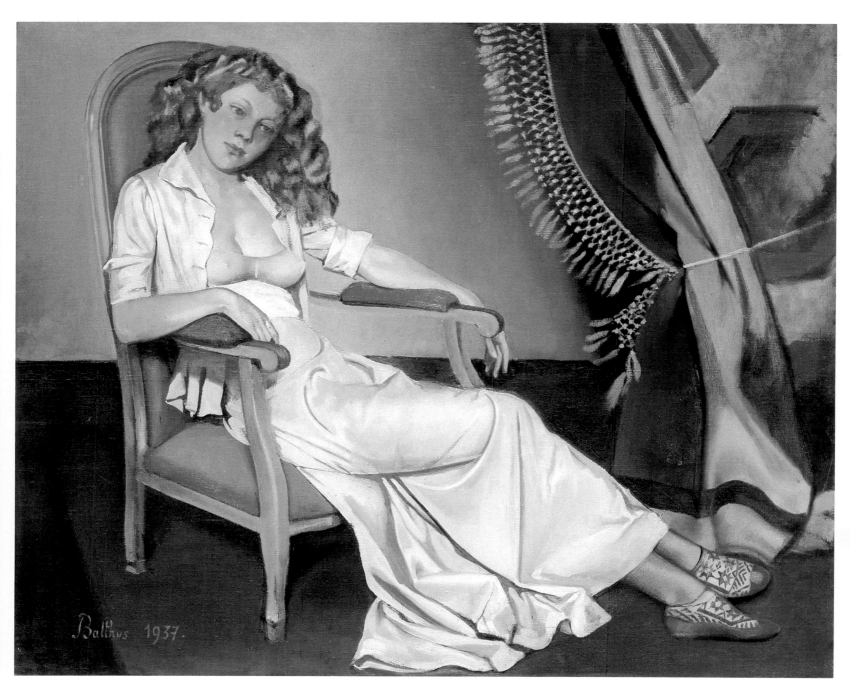

24 *La jupe blanche* 1937

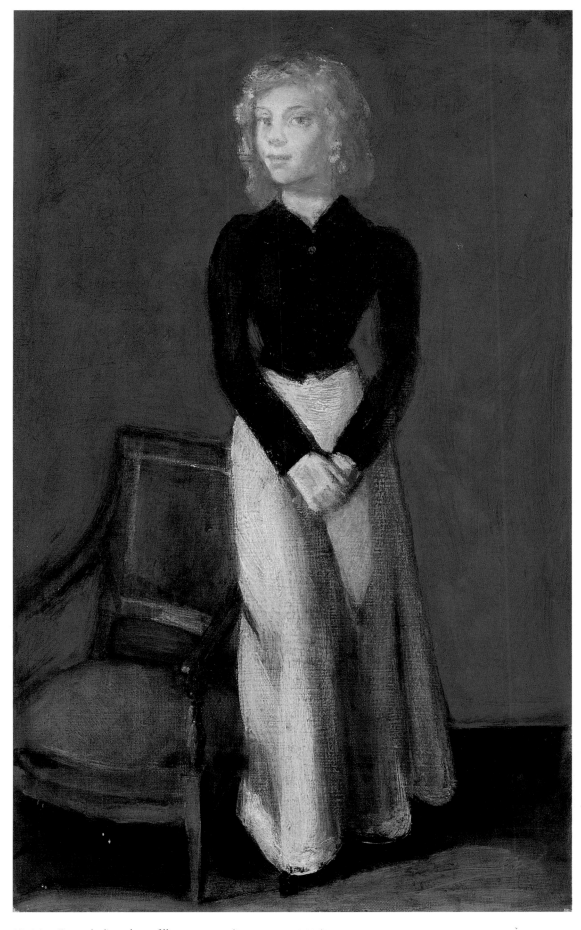

25, 26 *Portrait d'une jeune fille en costume d'amazone* 1932/1981

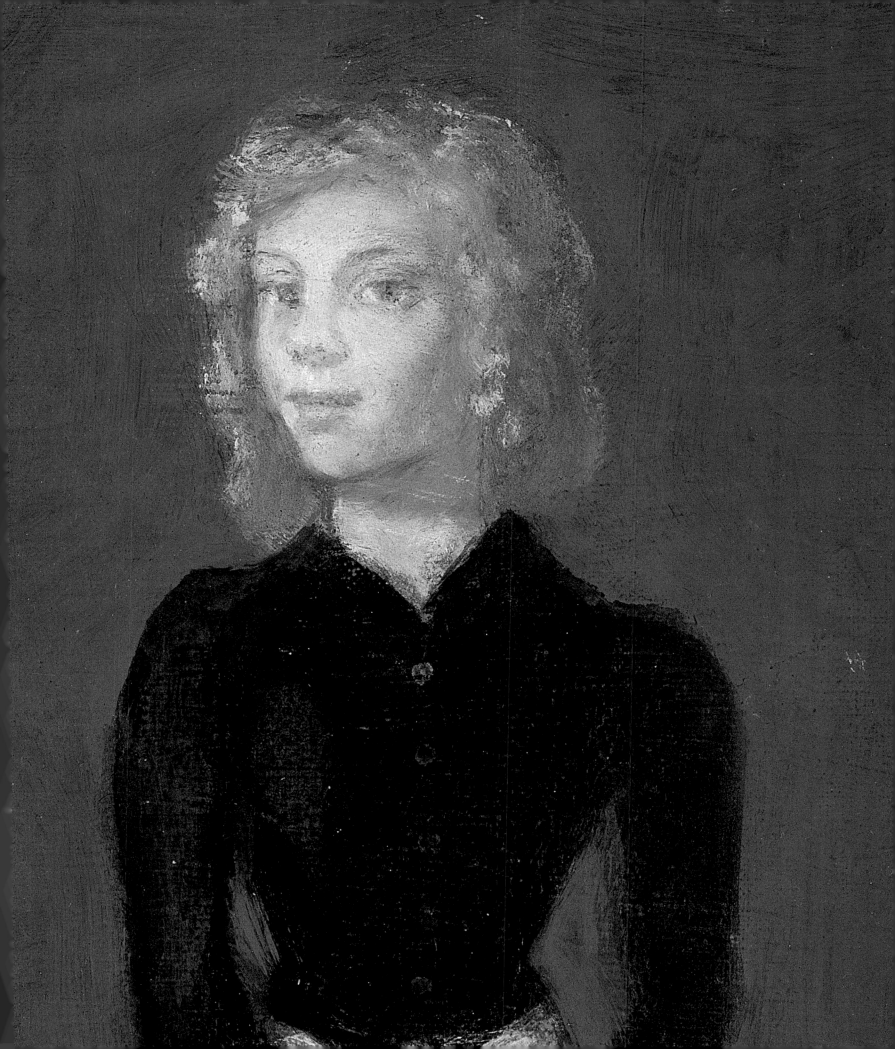

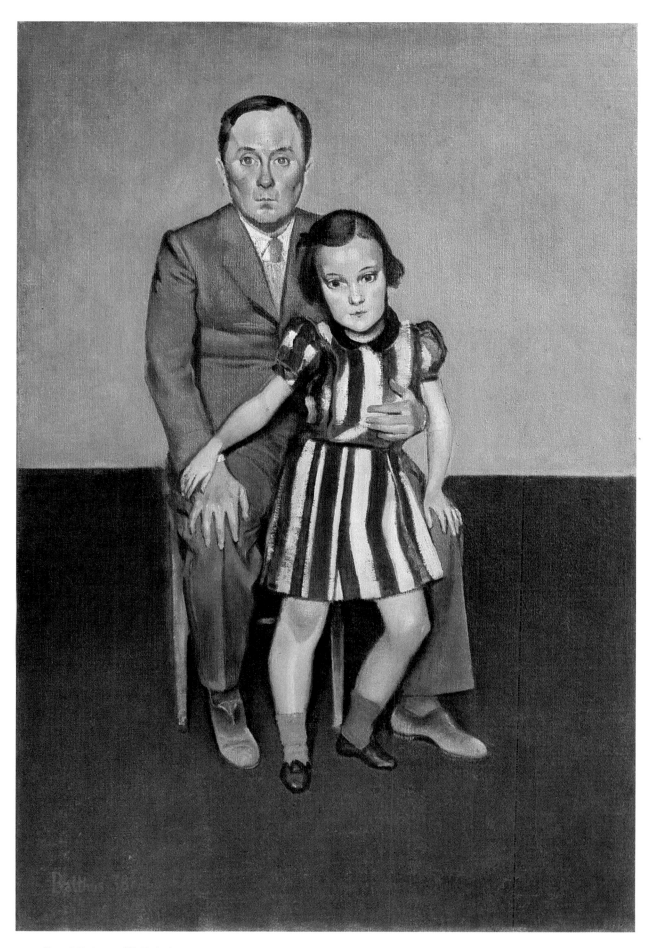

27 *Joan Miró et sa fille Dolorès* 1937–38

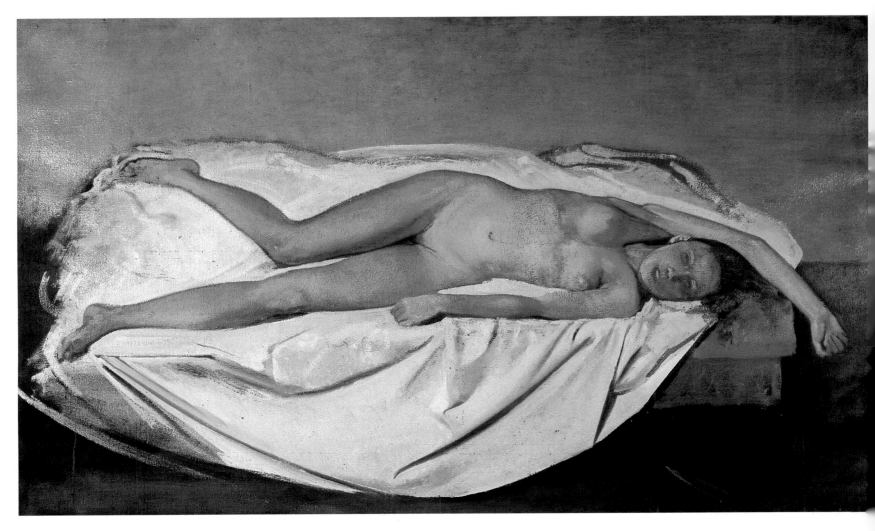

28 *La victime* 1938

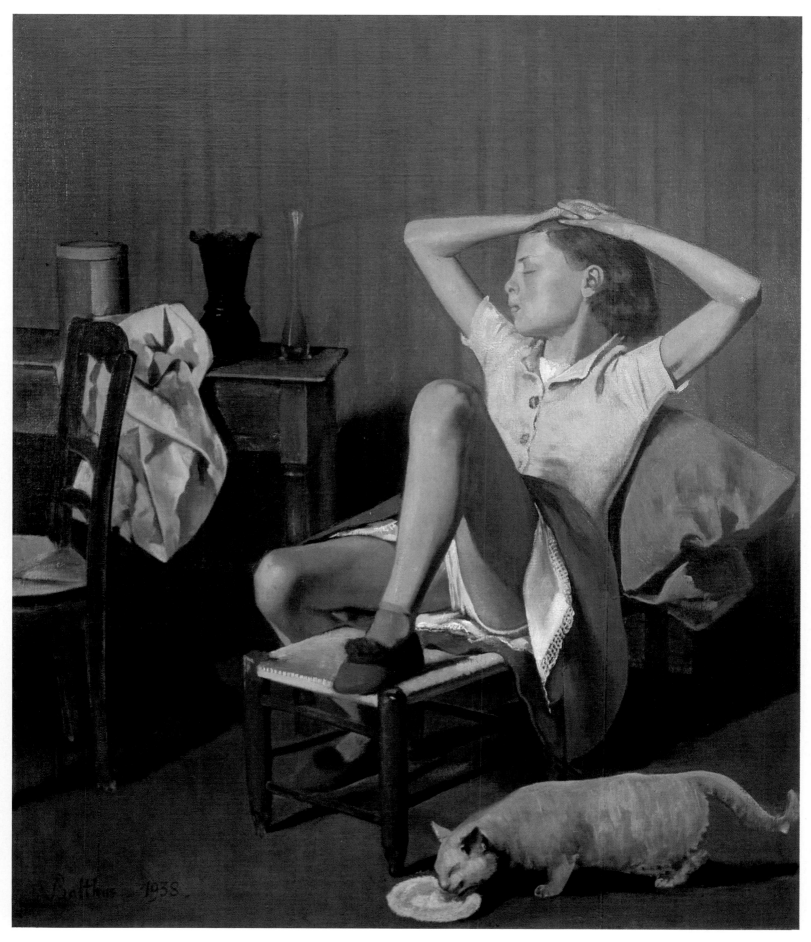

29 *Thérèse rêvant* 1938

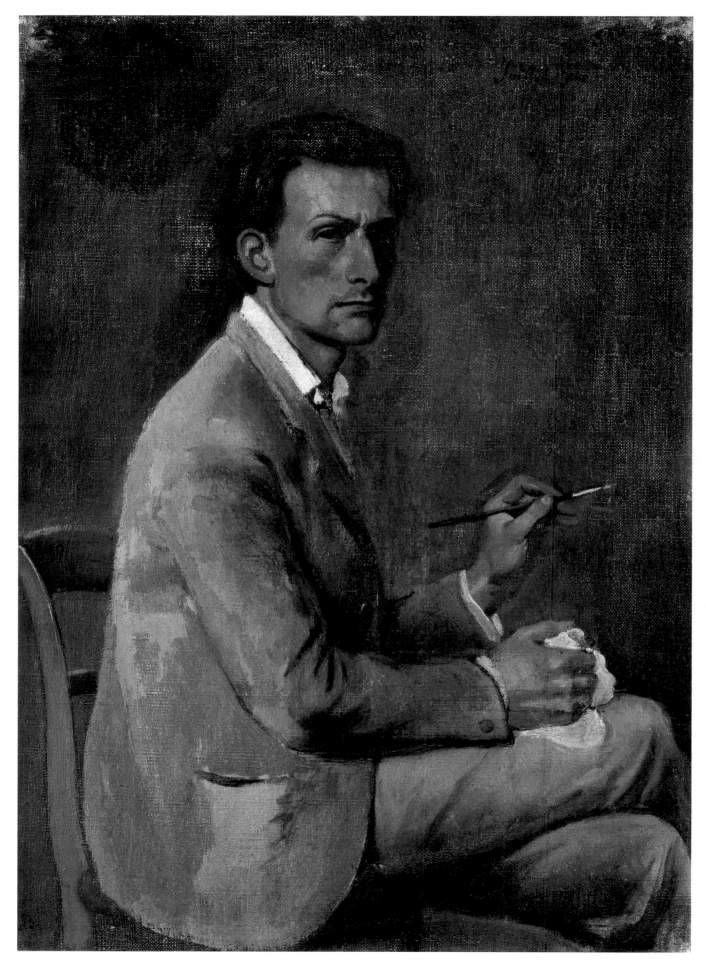

30 30, 31 *Autoportrait* 1940

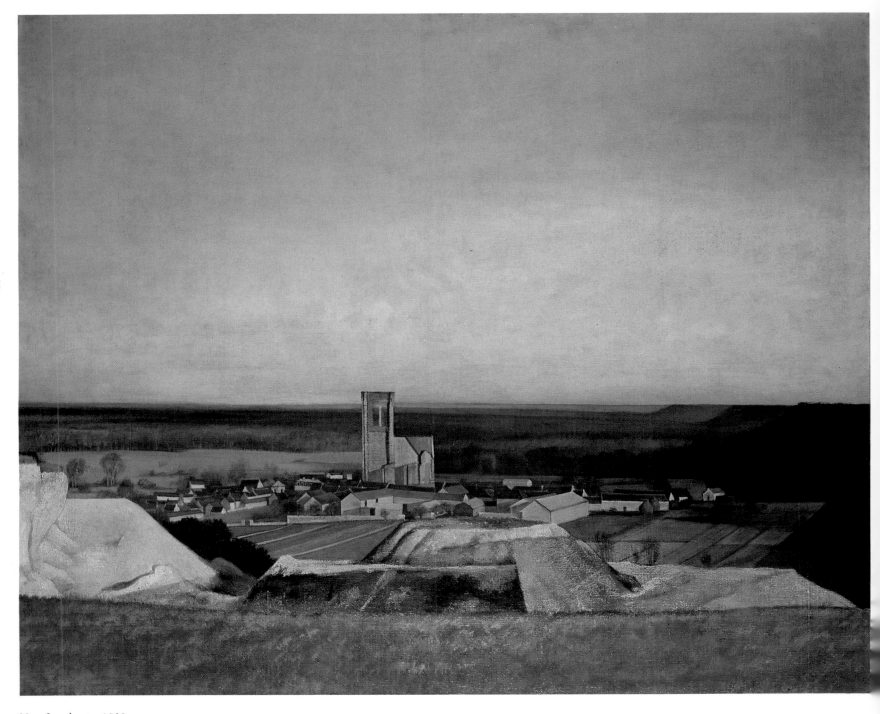

32 *Larchant* 1939

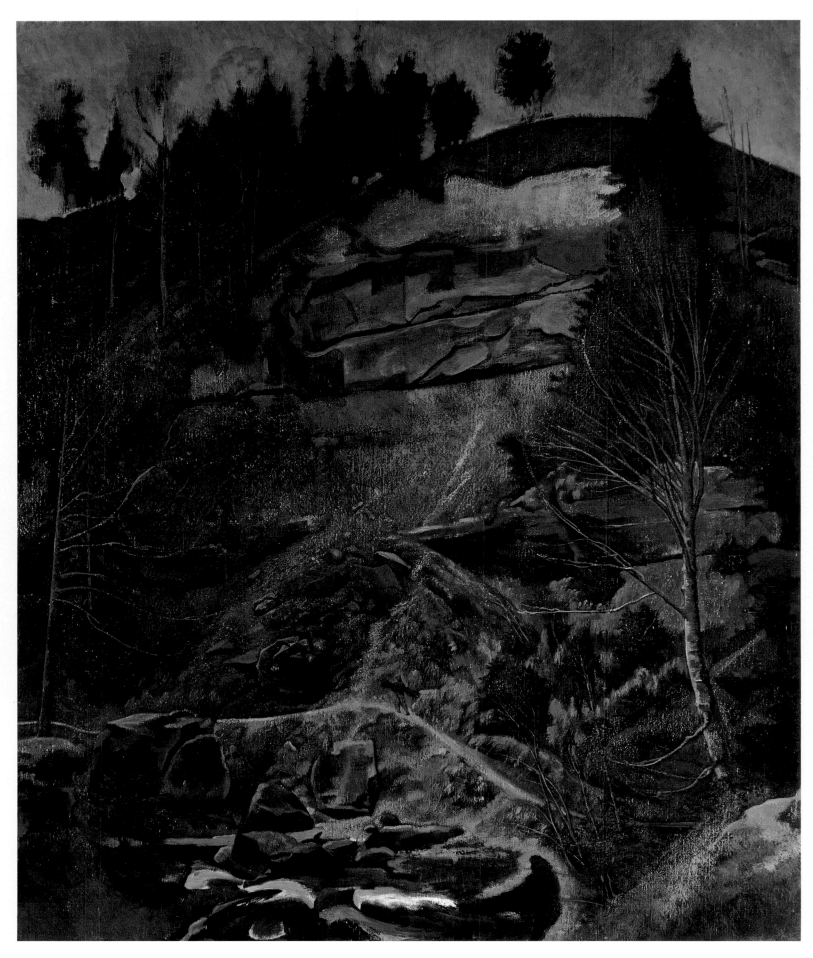

33 *Le Gottéron* 1943

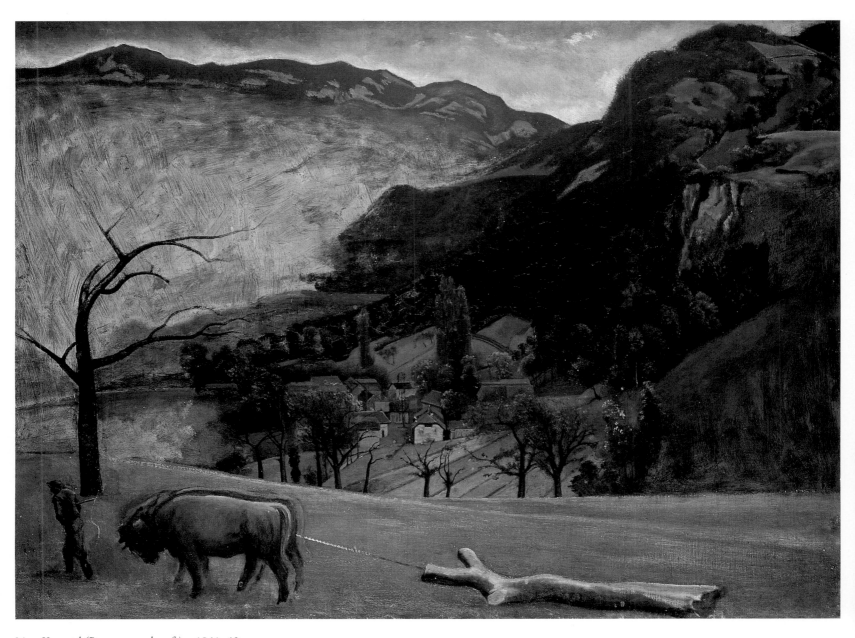

34 *Vernatel (Paysage aux boeufs)* 1941–42

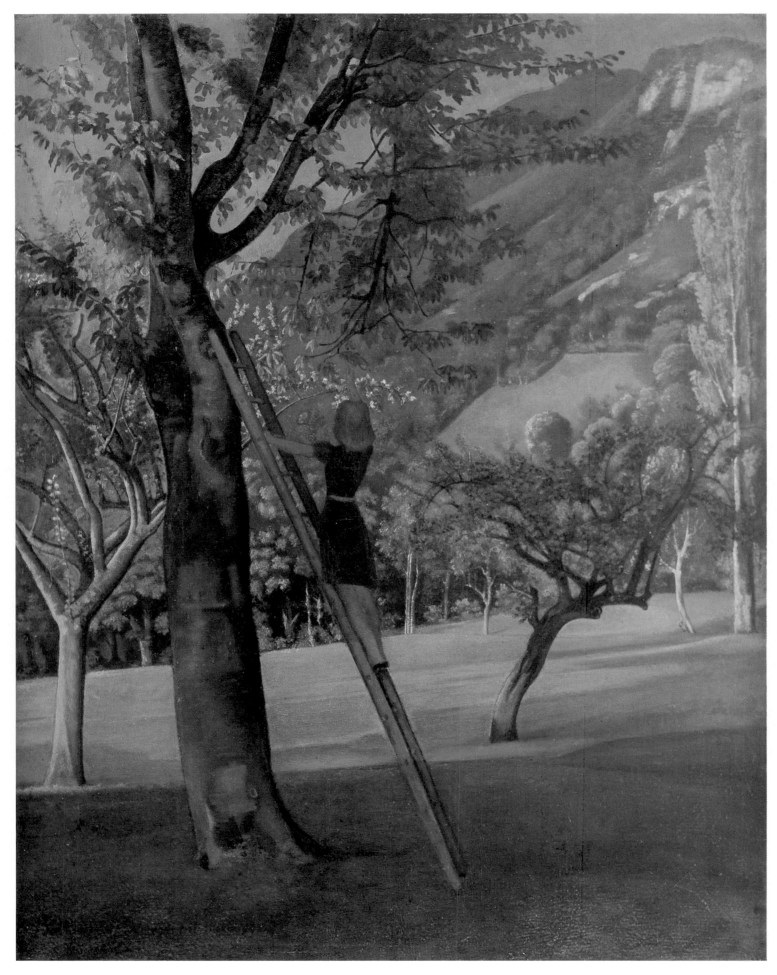

35 *Le cerisier* 1940

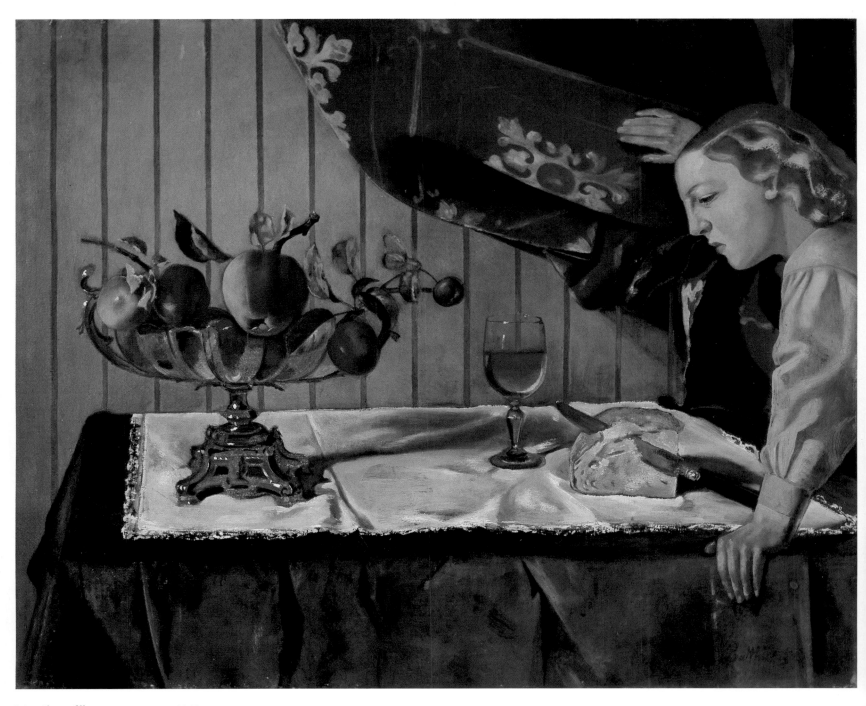

36 *Jeune fille et nature morte* 1942

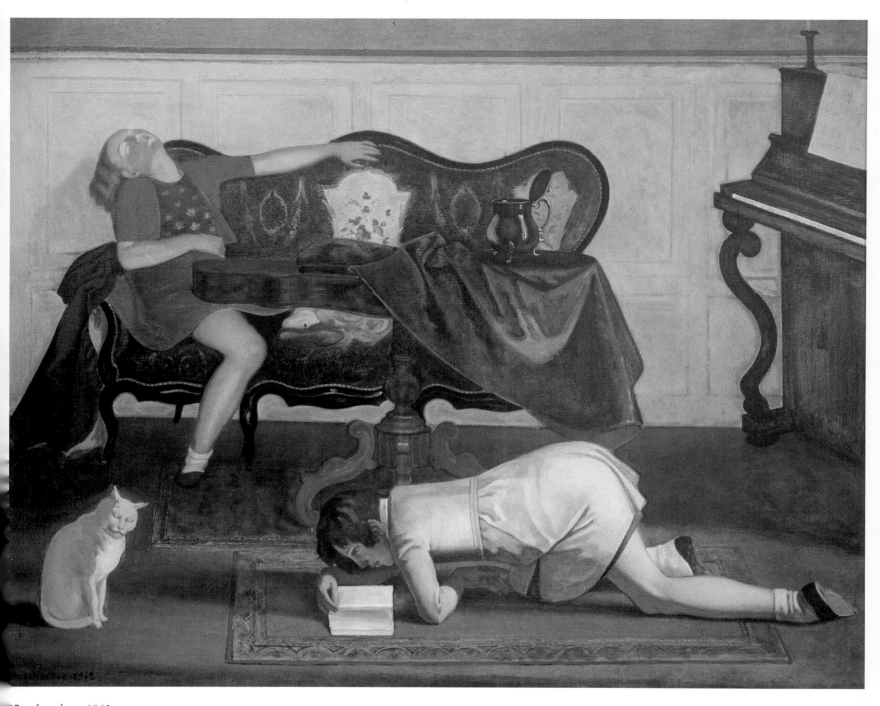

37 *Le salon* 1942

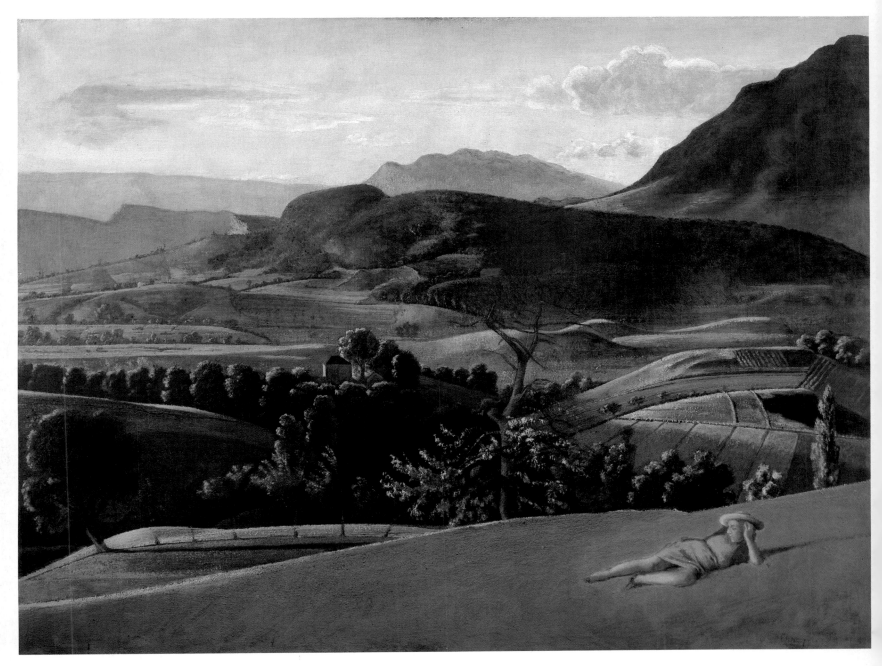

38, 39 *Paysage de Champrovent* 1942—45

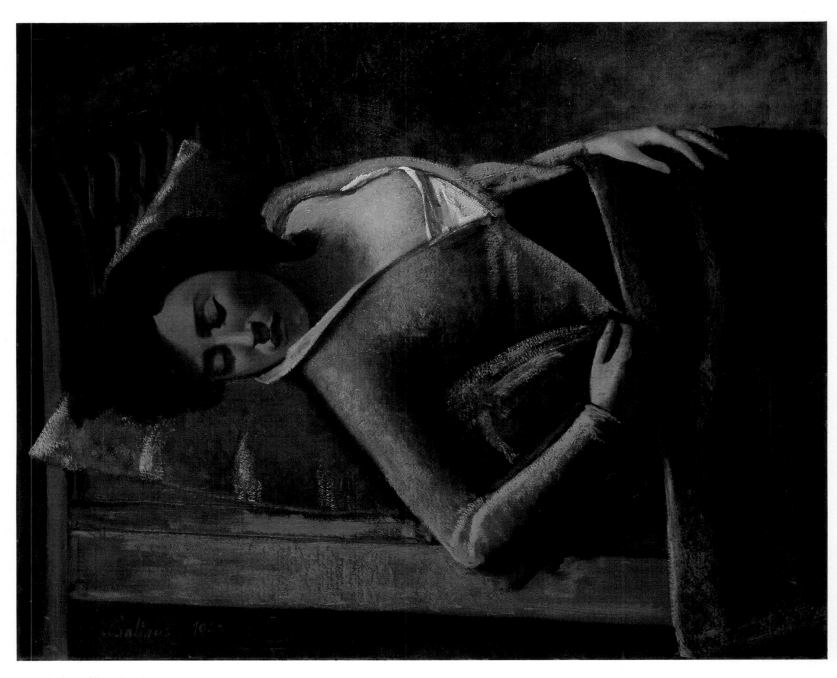

40 *La jeune fille endormie* 1943

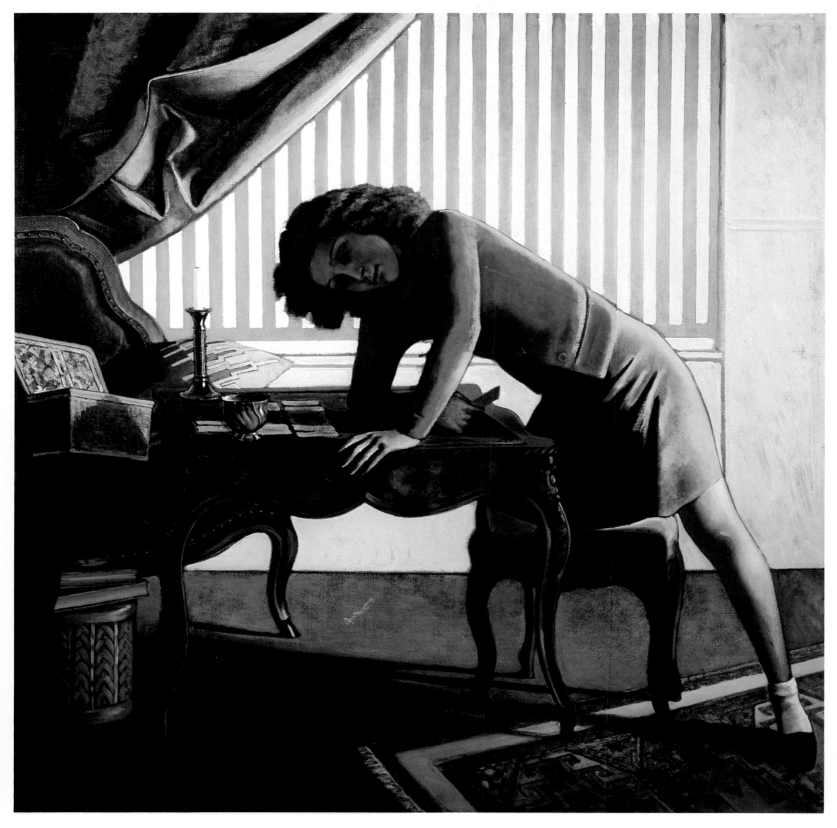

41 *La patience* 1943

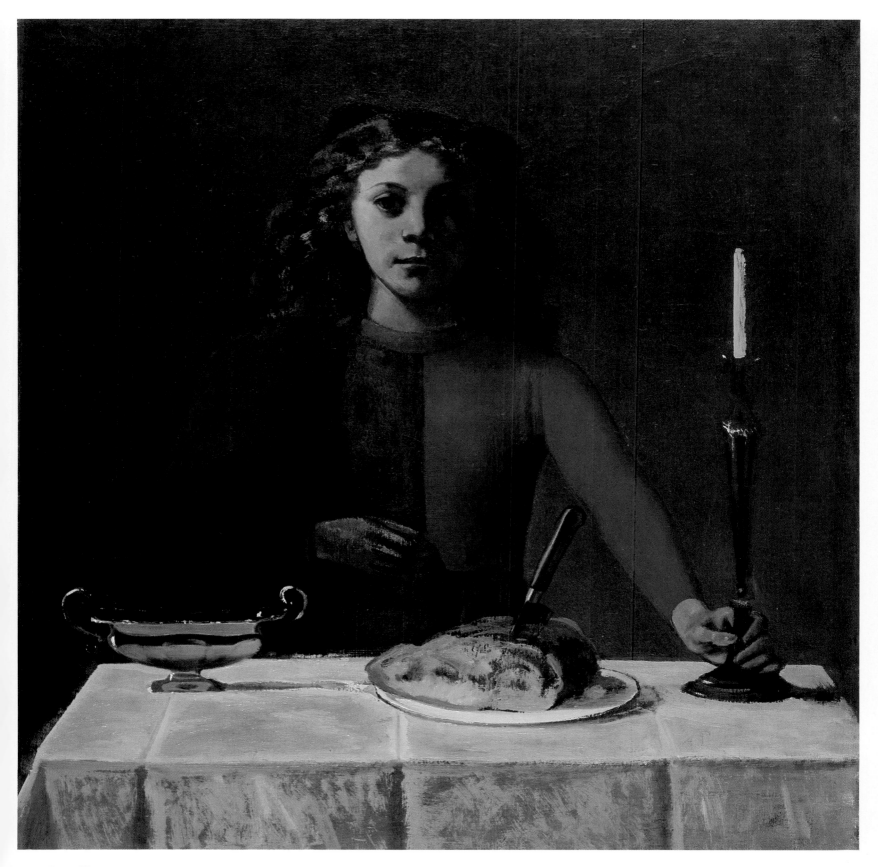

42 *Jeune fille en vert et rouge* 1944

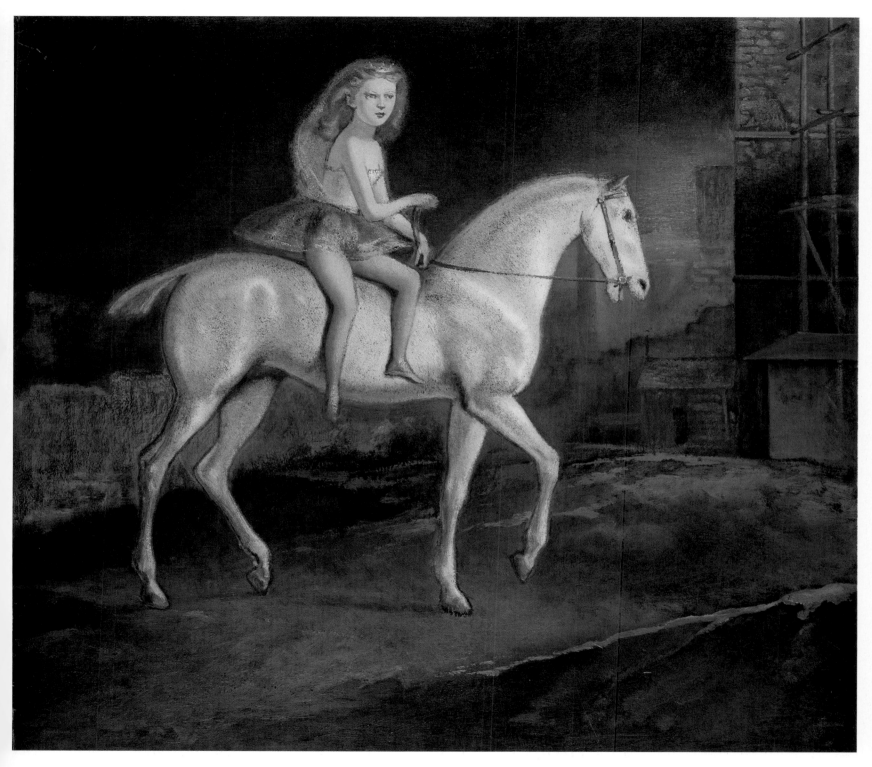

43 *L'écuyère* 1944

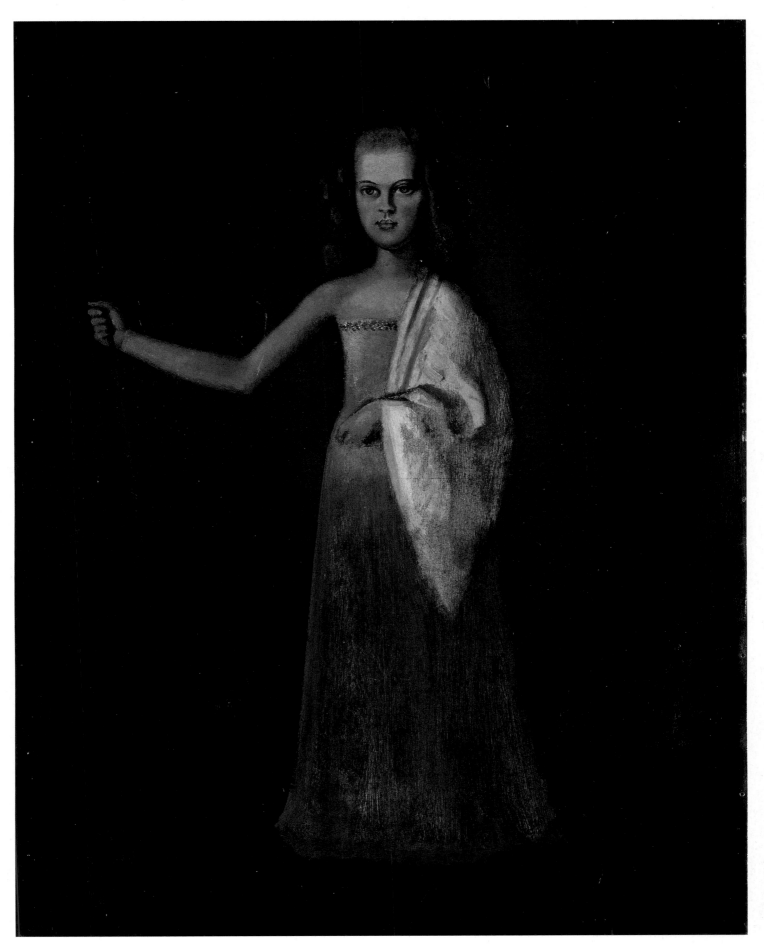

44, 45 *La princesse Maria Volkonski à l'âge de douze ans* 1945

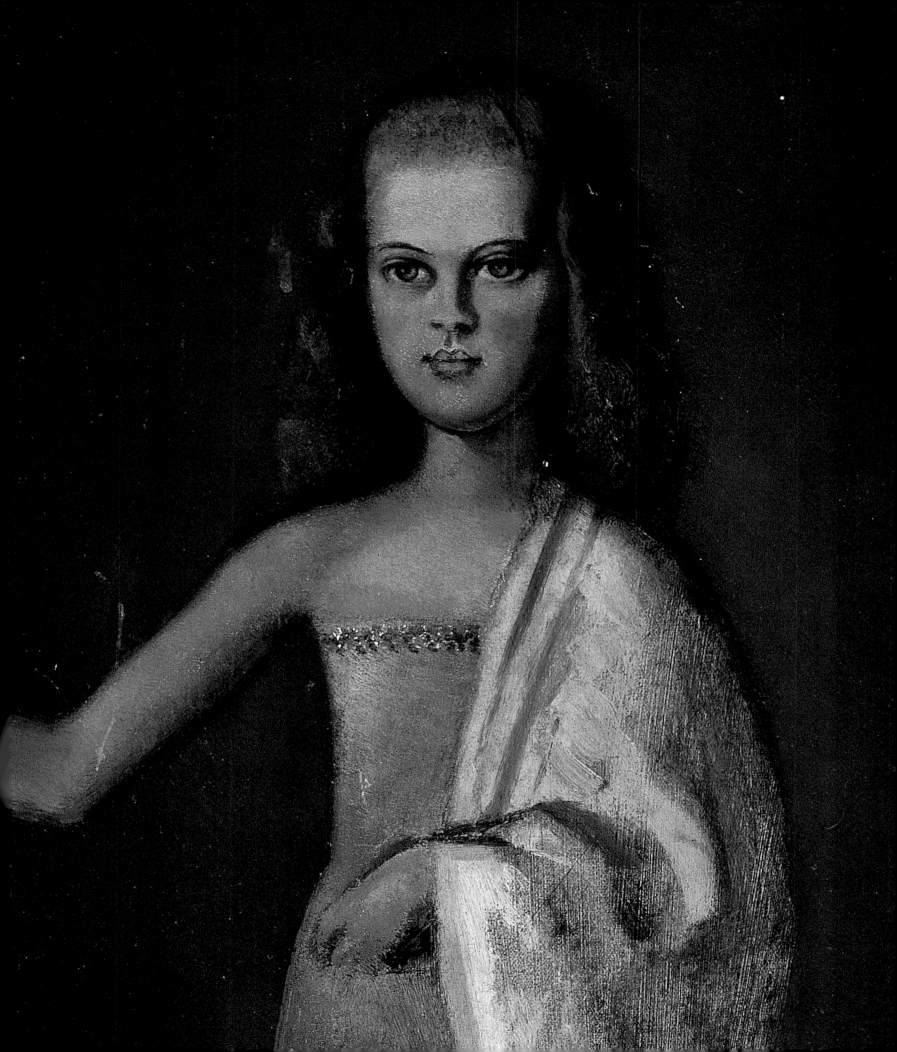

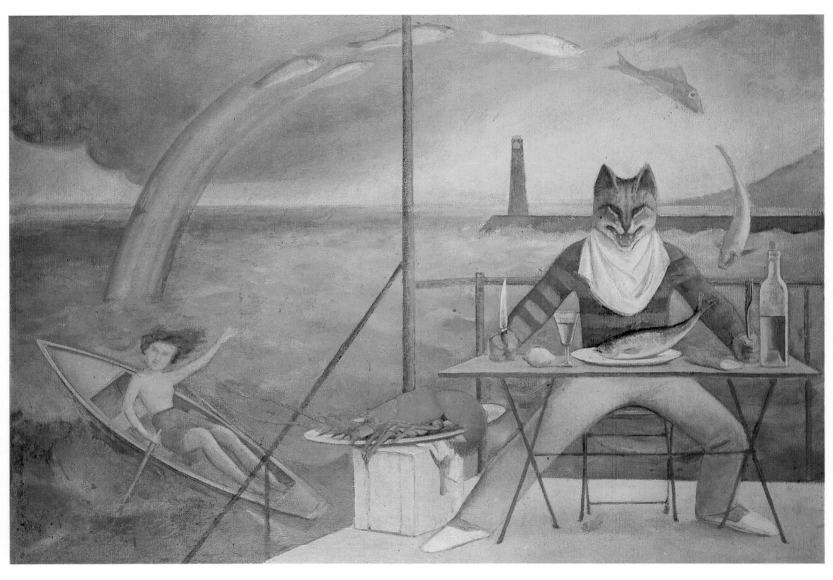

46 *Le chat de La Méditerranée* 1949

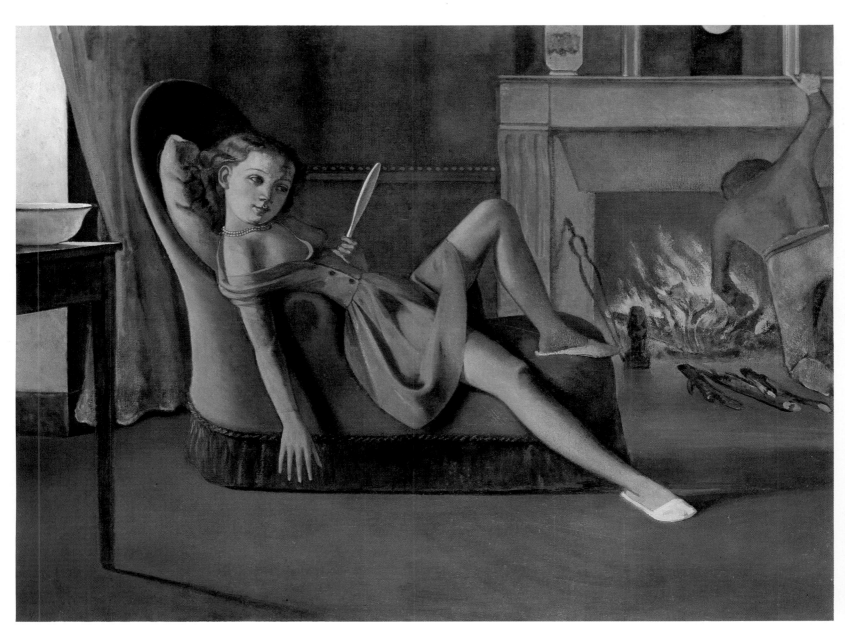

47 *Les beaux jours* 1944–45

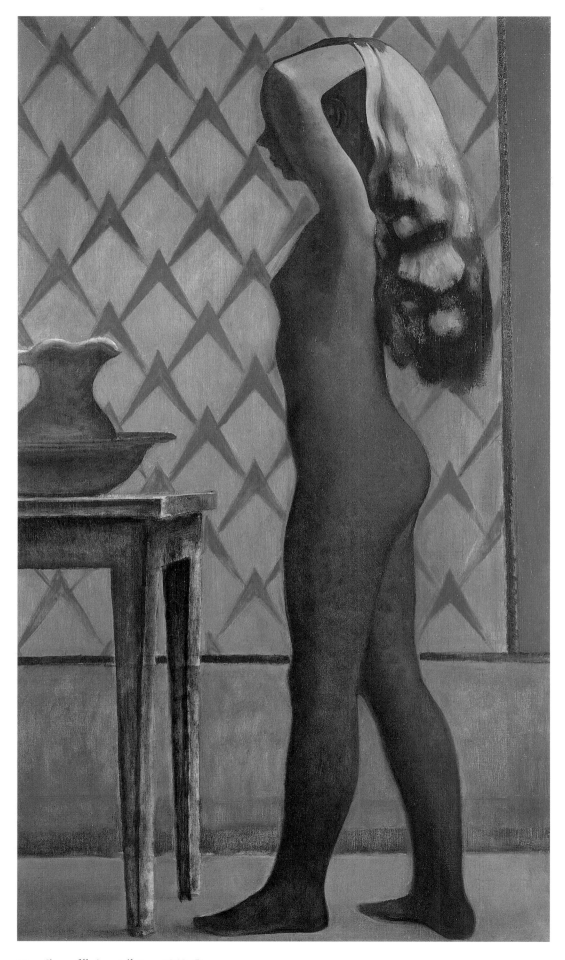

48 *Jeune fille à sa toilette* 1949–51

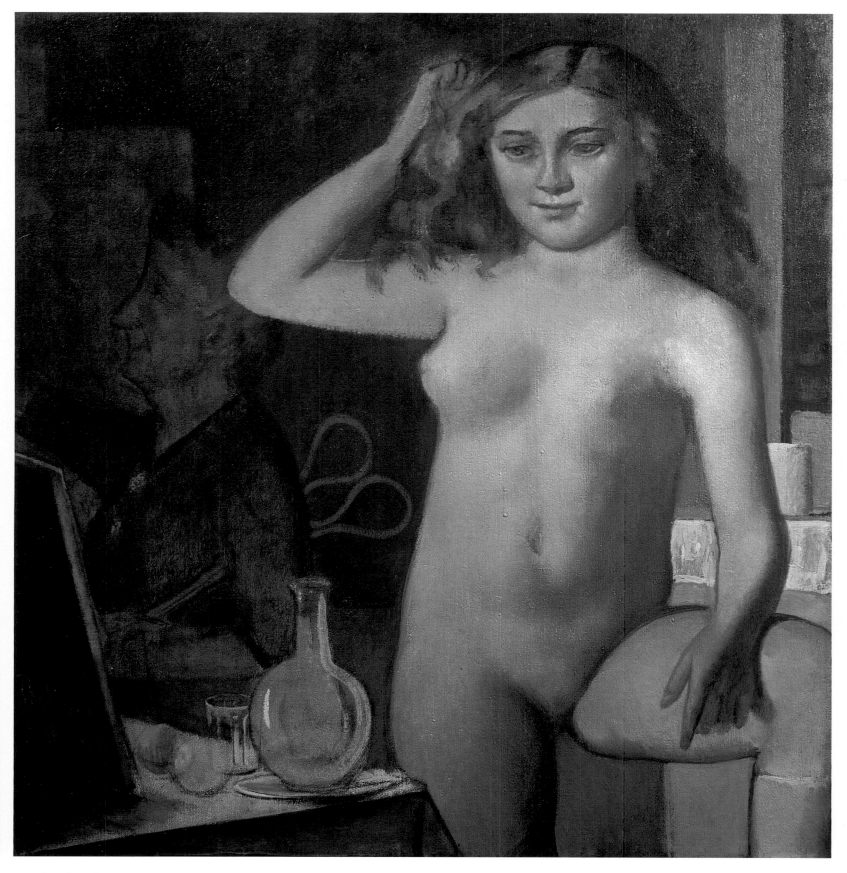

49 *La toilette de Georgette* 1948–49

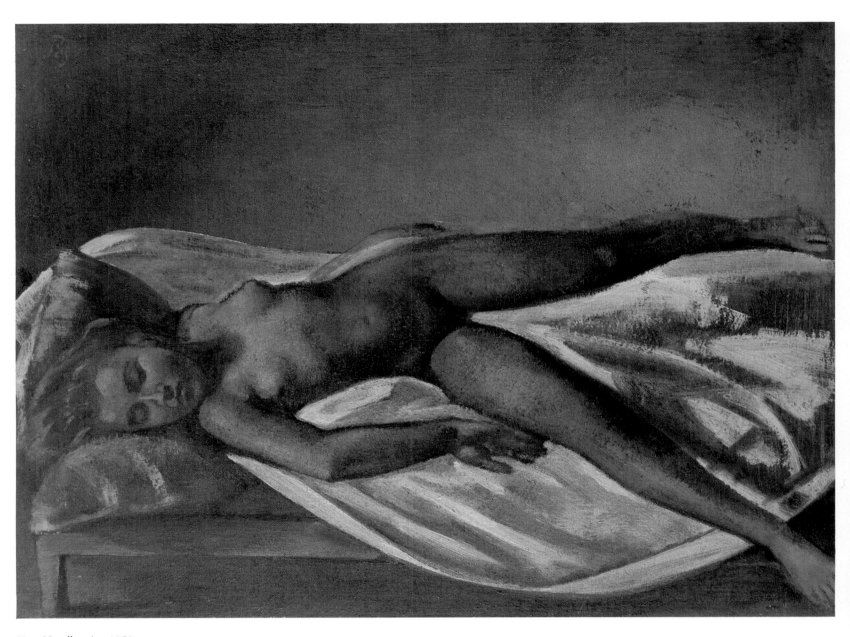

50 *Nu allongé* 1950

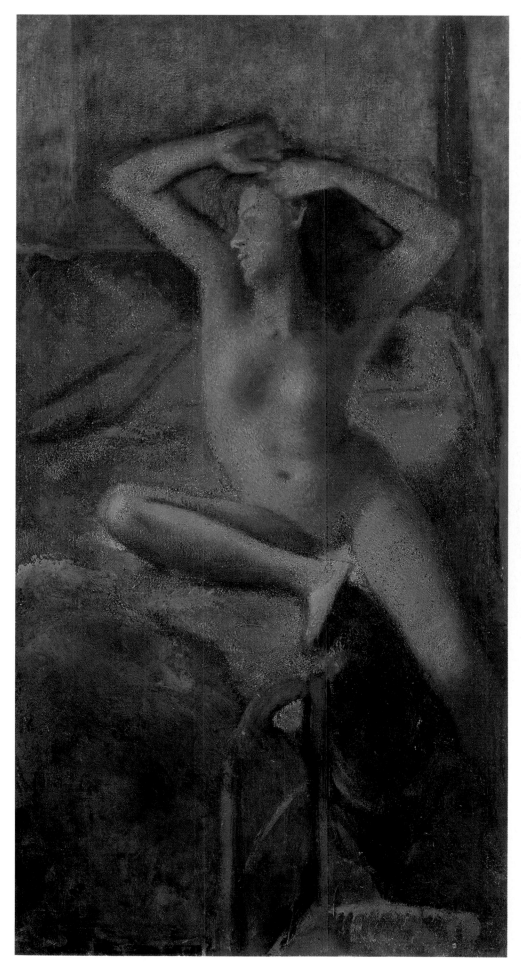

51 *Nu aux bras levés* 1951

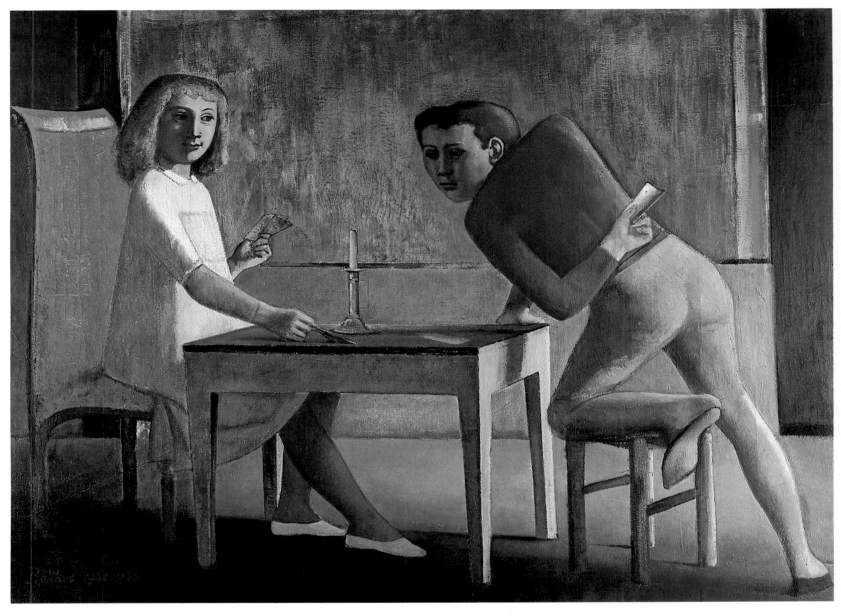

52 *La partie de cartes* 1948–50

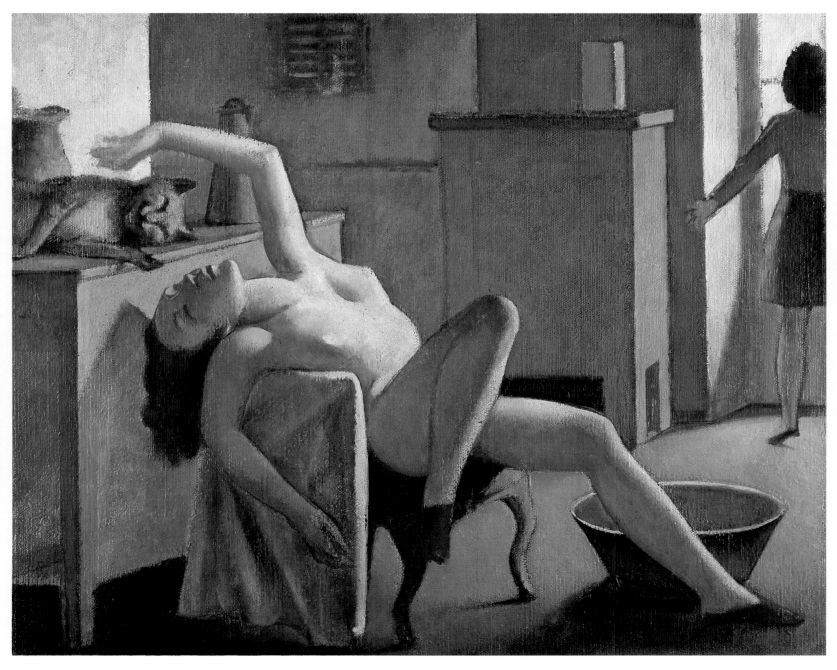

53 *Nu jouant avec un chat* 1949

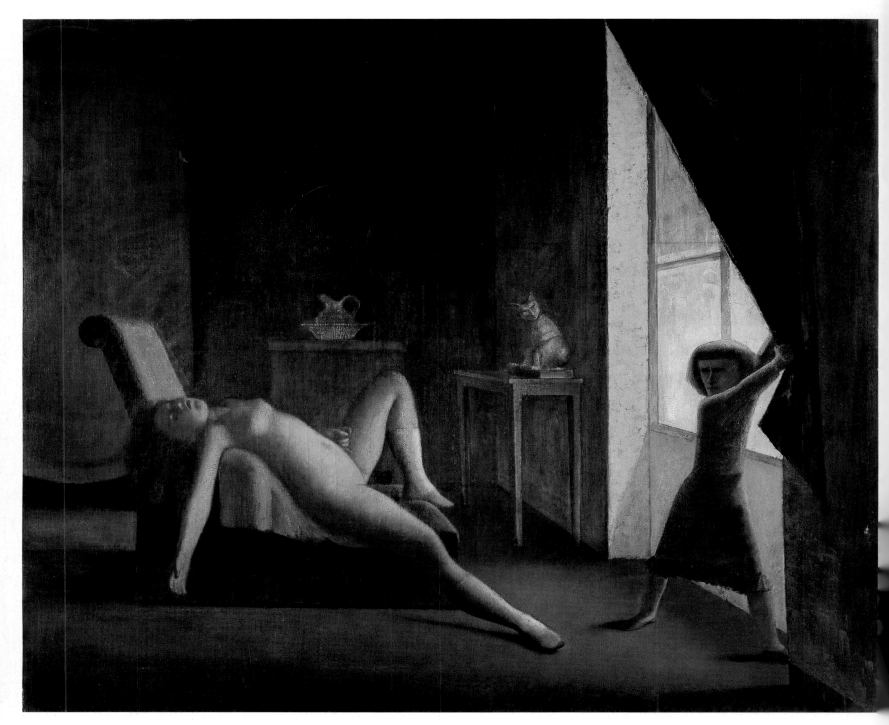

54, 55 *La chambre* 1952–54

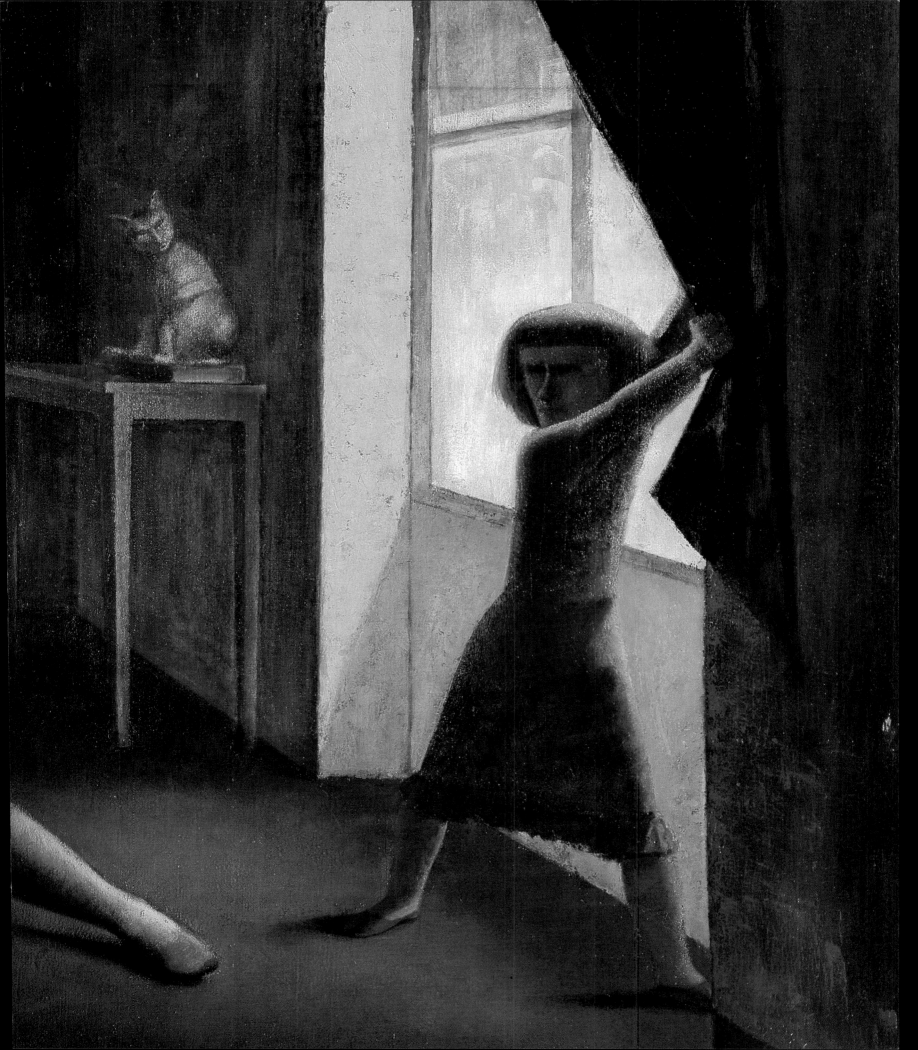

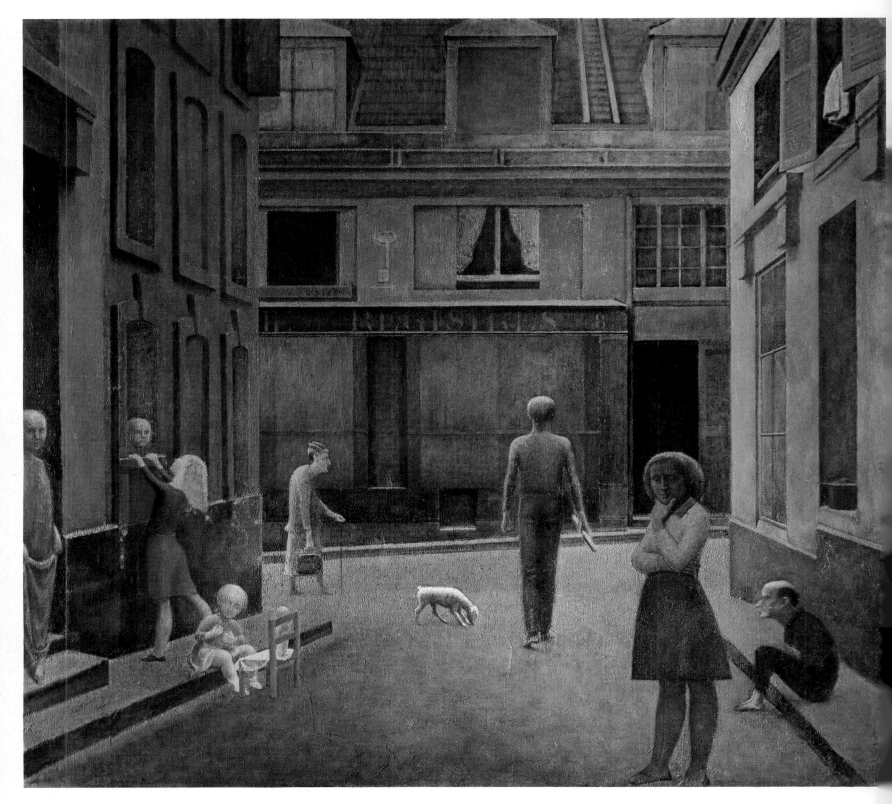

56, 57 *Le passage du Commerce Saint-André* 1952–54

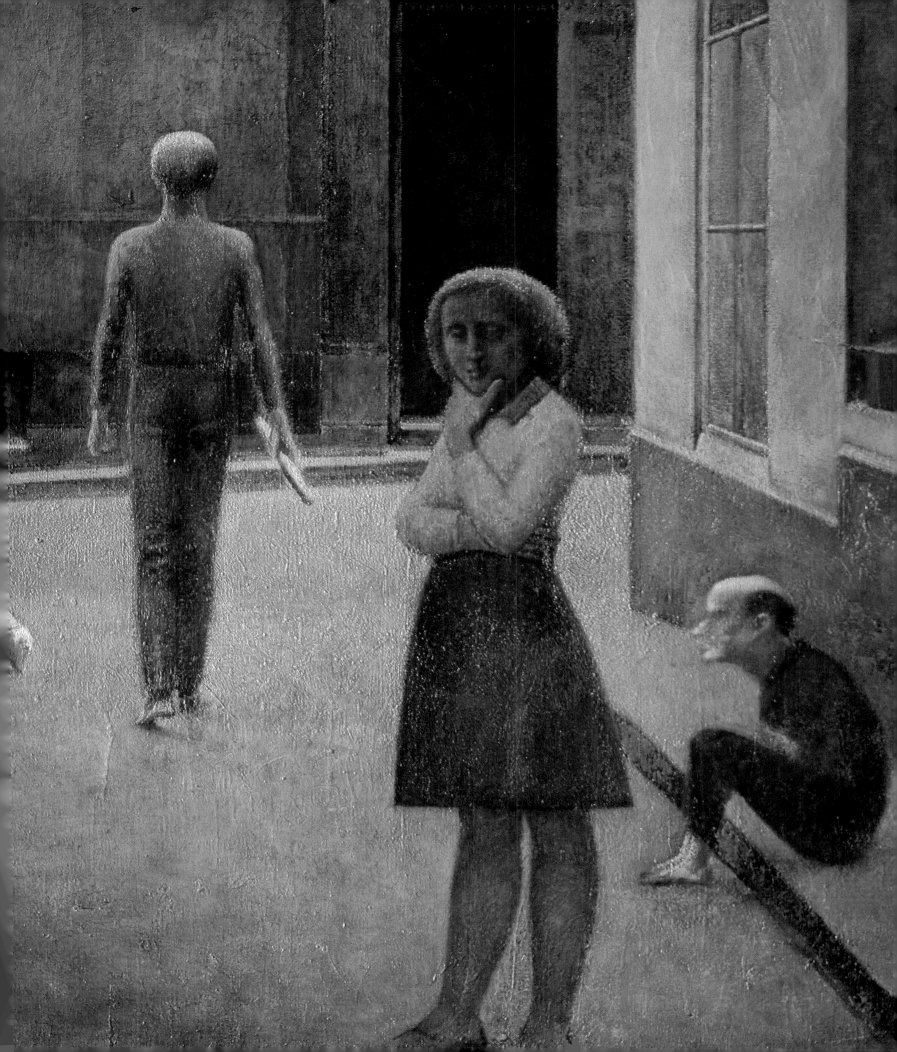

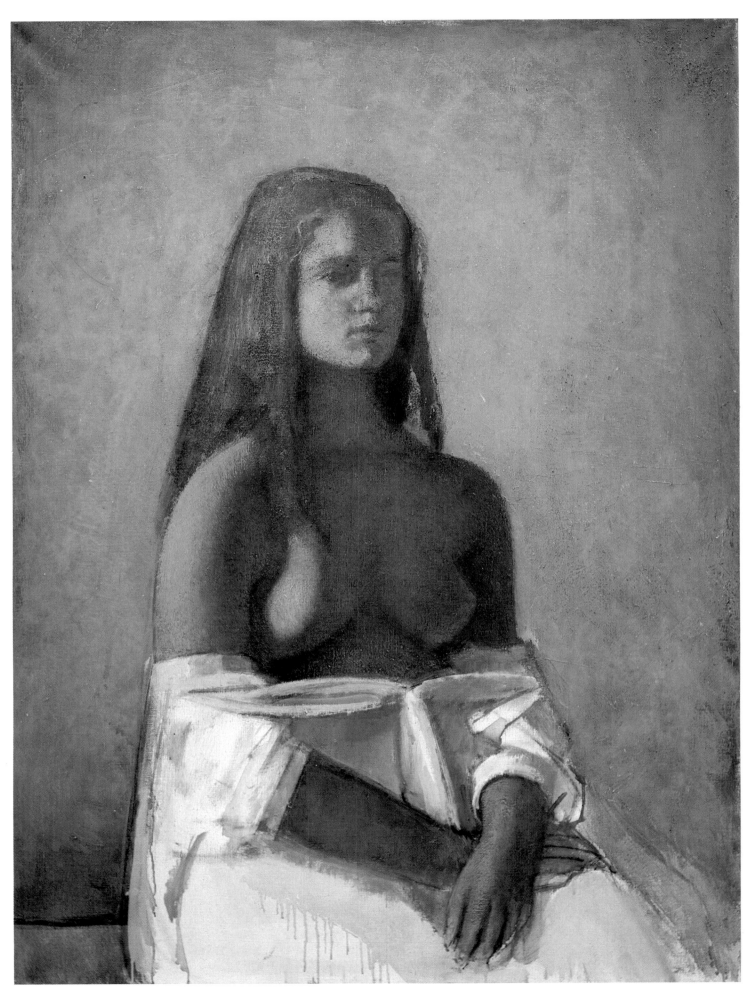

58 *Jeune fille à la chemise blanche* 1955

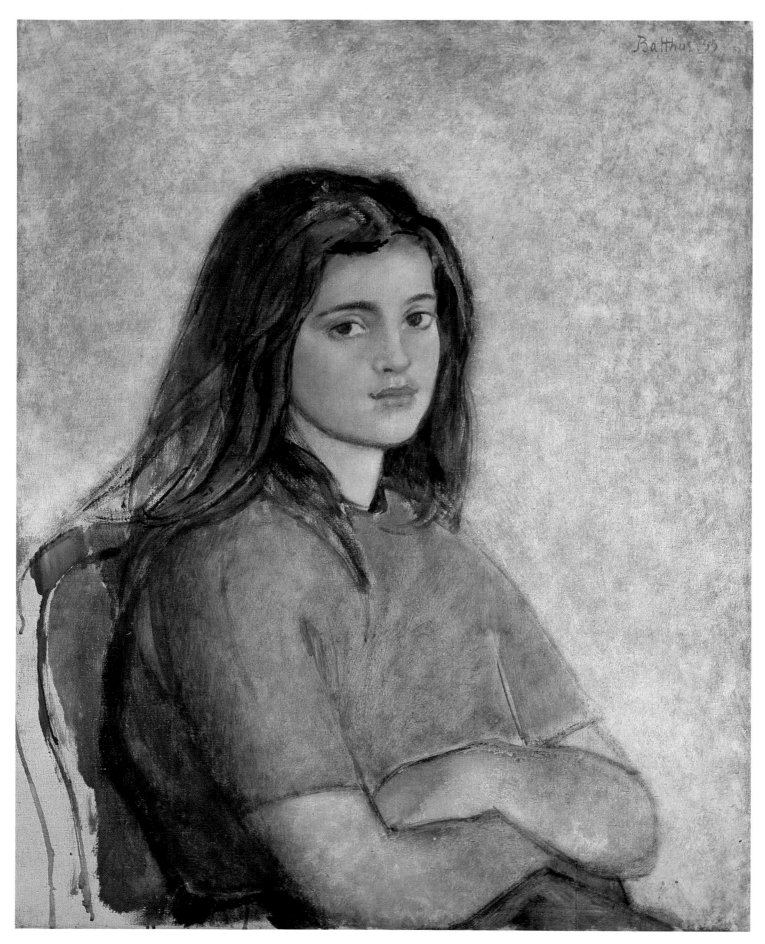

59 *Frédérique* 1955

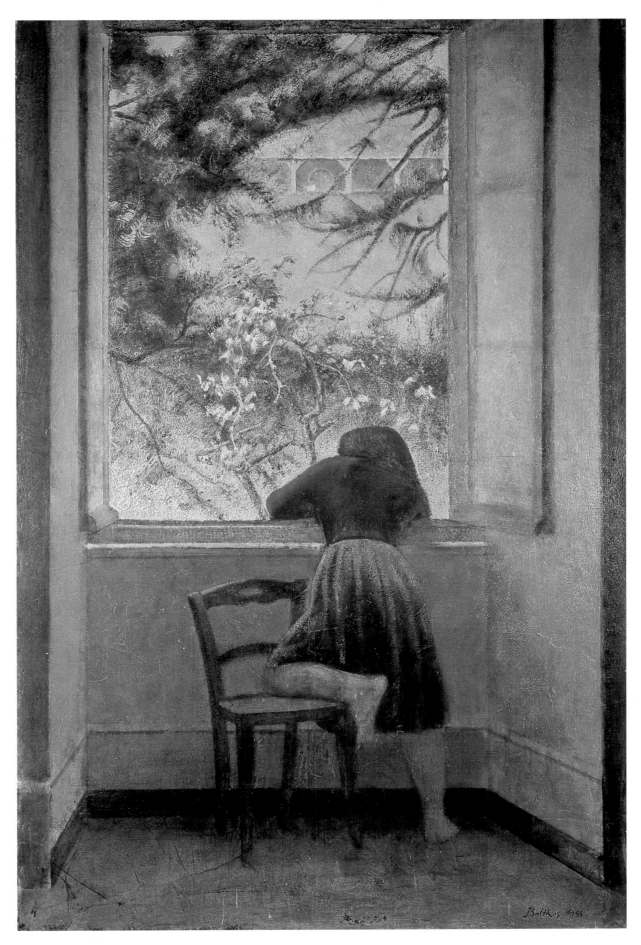

60 *Jeune fille à la fenêtre* 1955

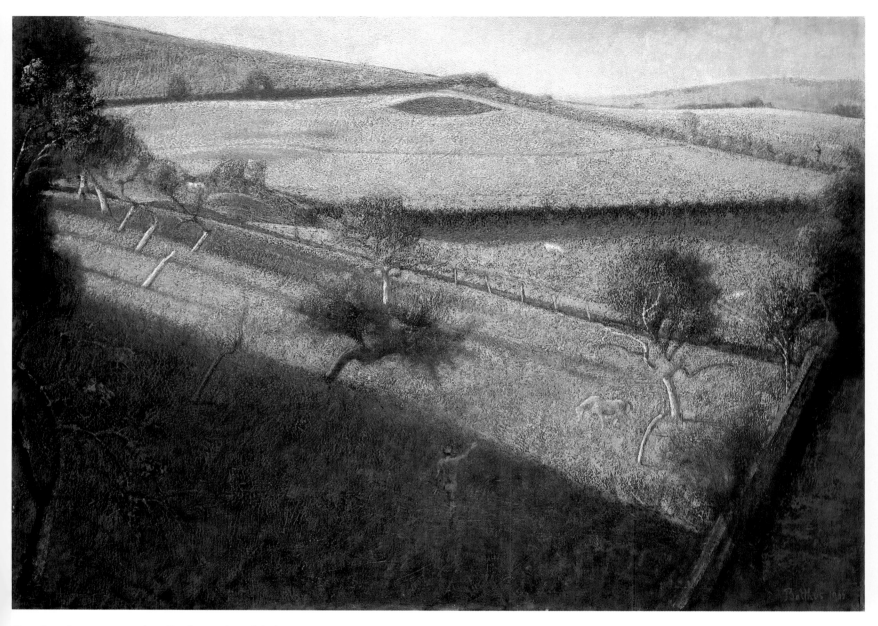

61 *Grand paysage aux arbres (Le champ triangulaire)* 1955

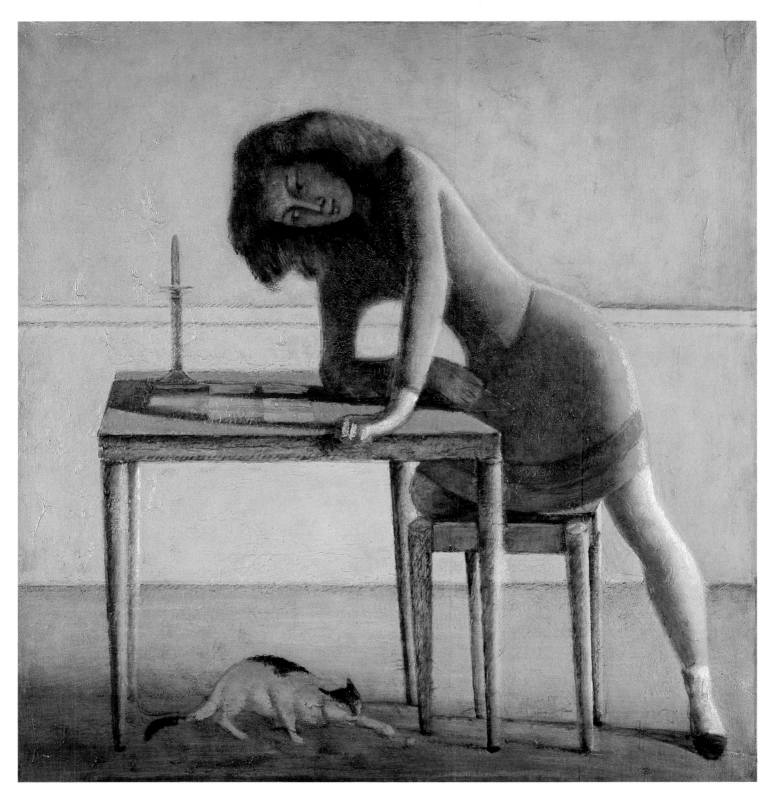

62 *La patience* 1954–55

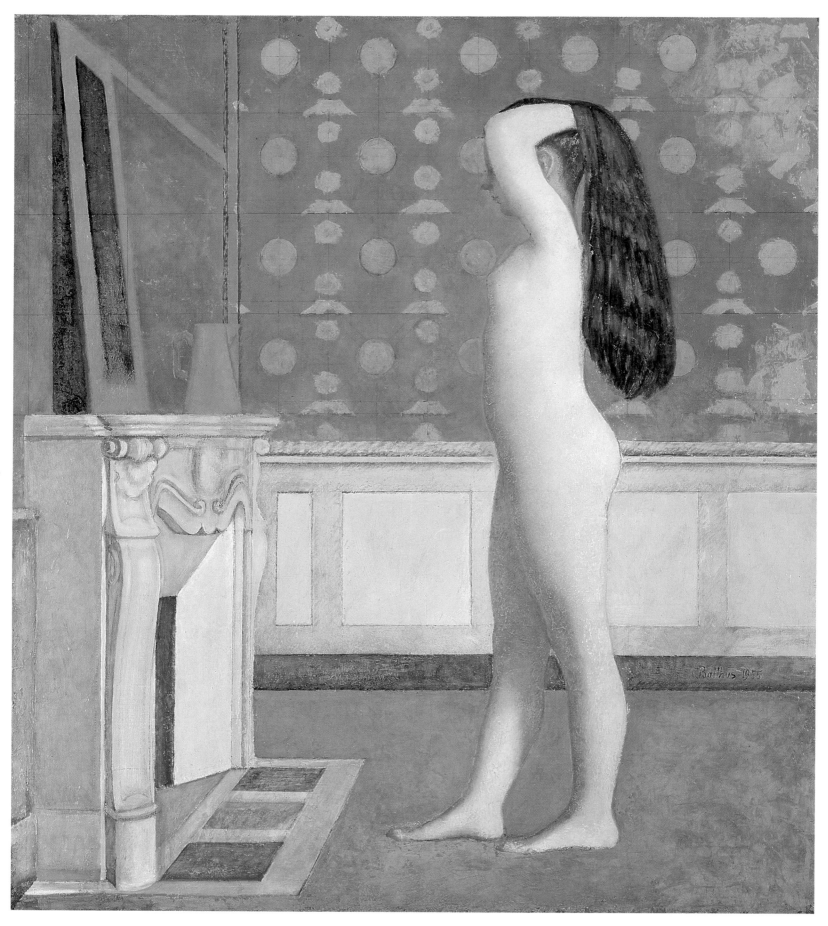

63 *Nu devant la cheminée* 1955

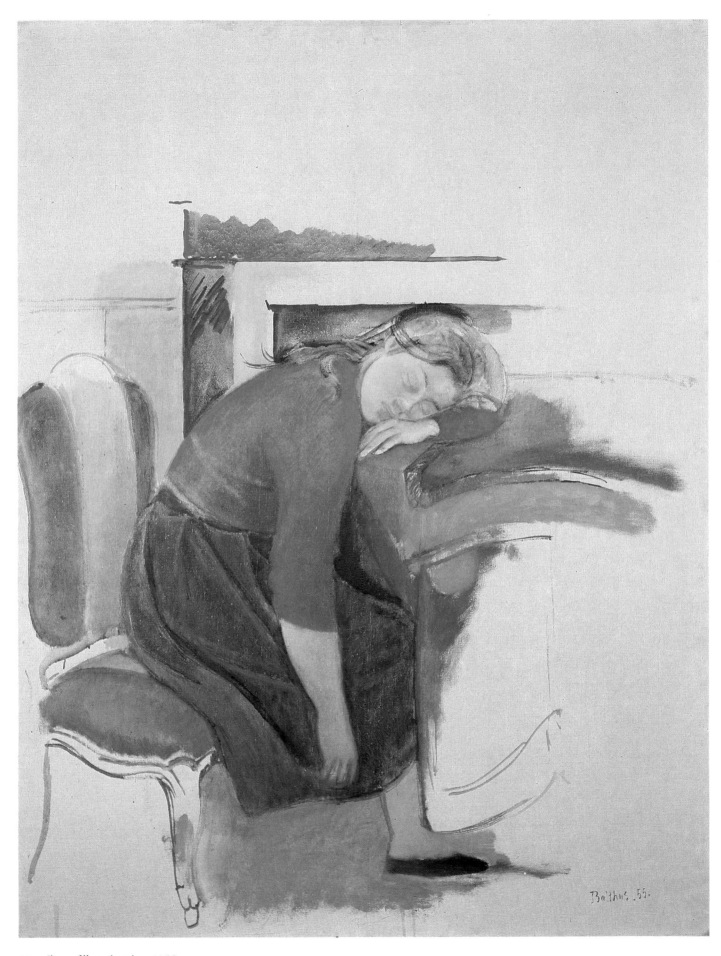

64 *Jeune fille endormie* 1955

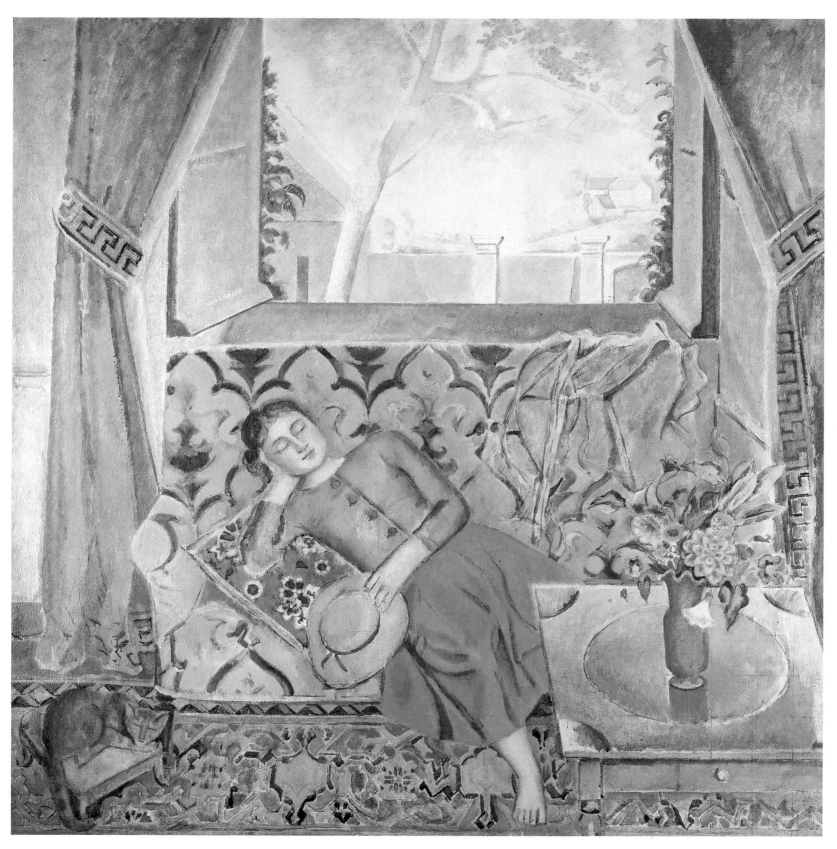

65 *Golden Afternoon* 1957

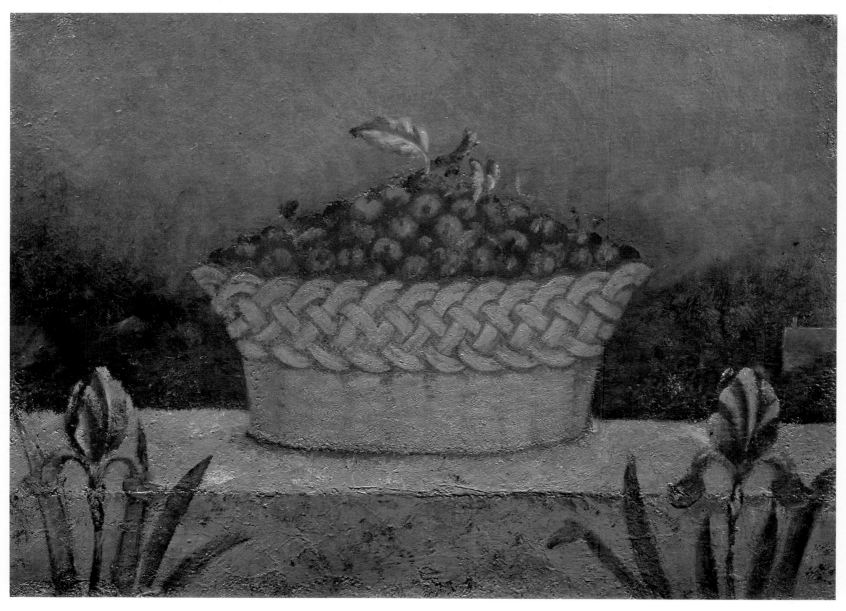

66 *Nature morte* *c.* 1956

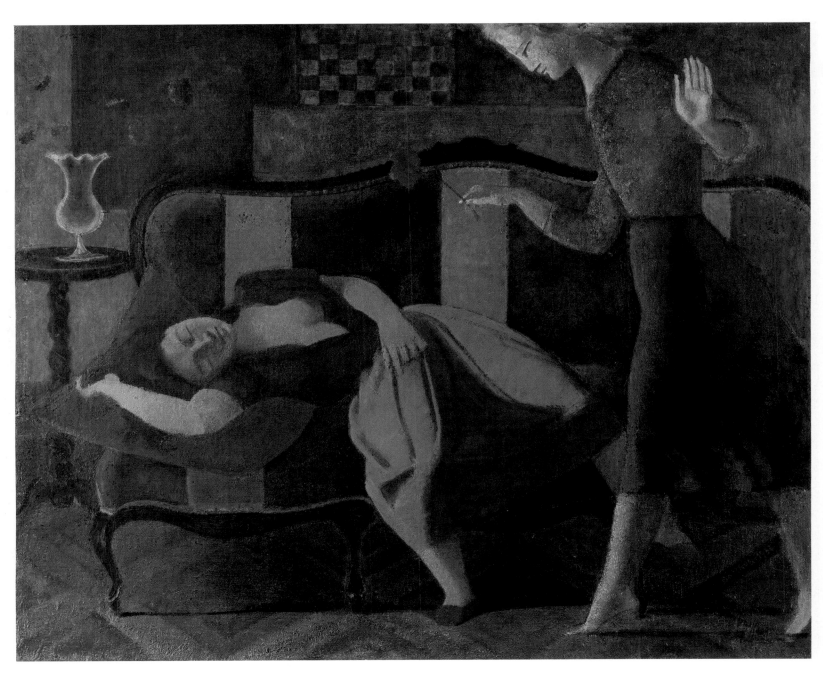

67 *Le rêve I* 1955

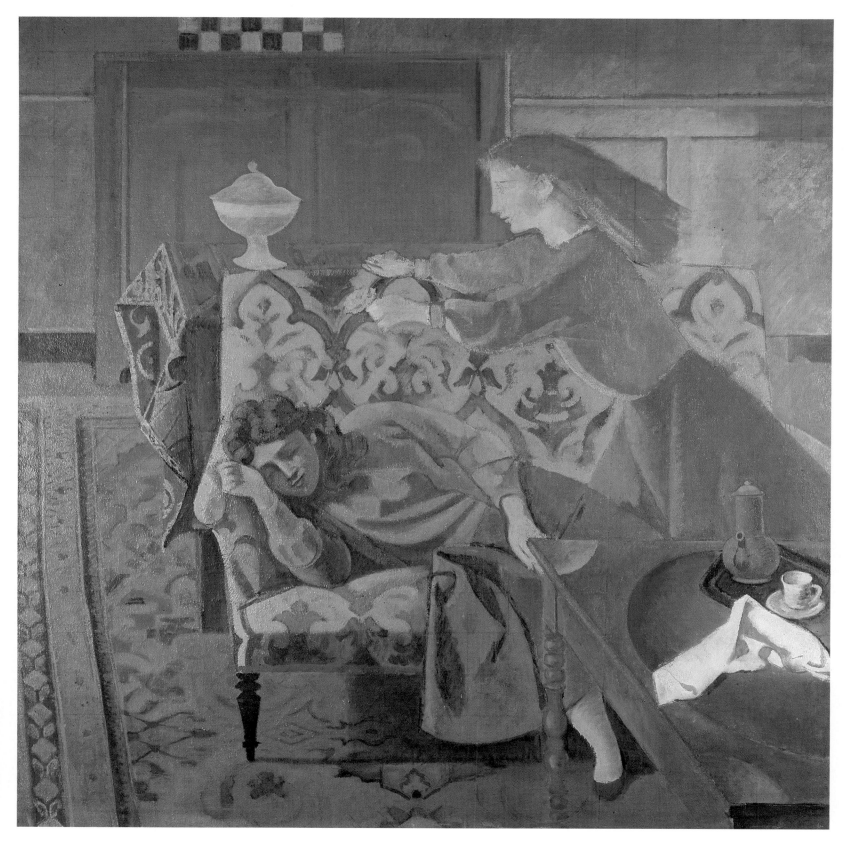

68 *Le rêve II* 1956–57

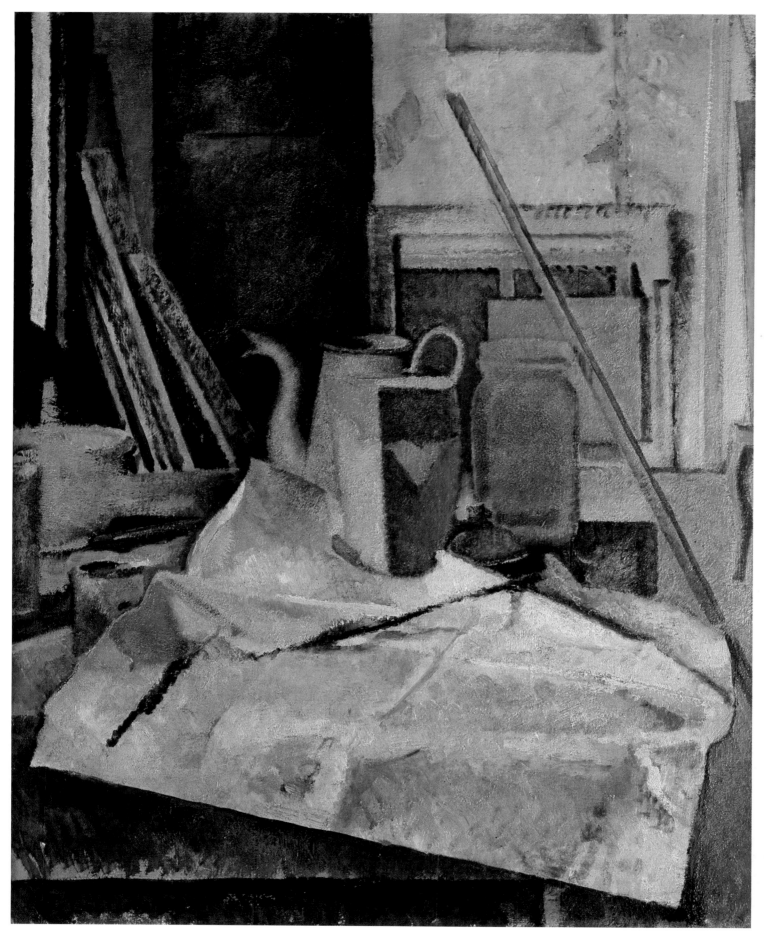

69 *Nature morte dans l'atelier* 1958

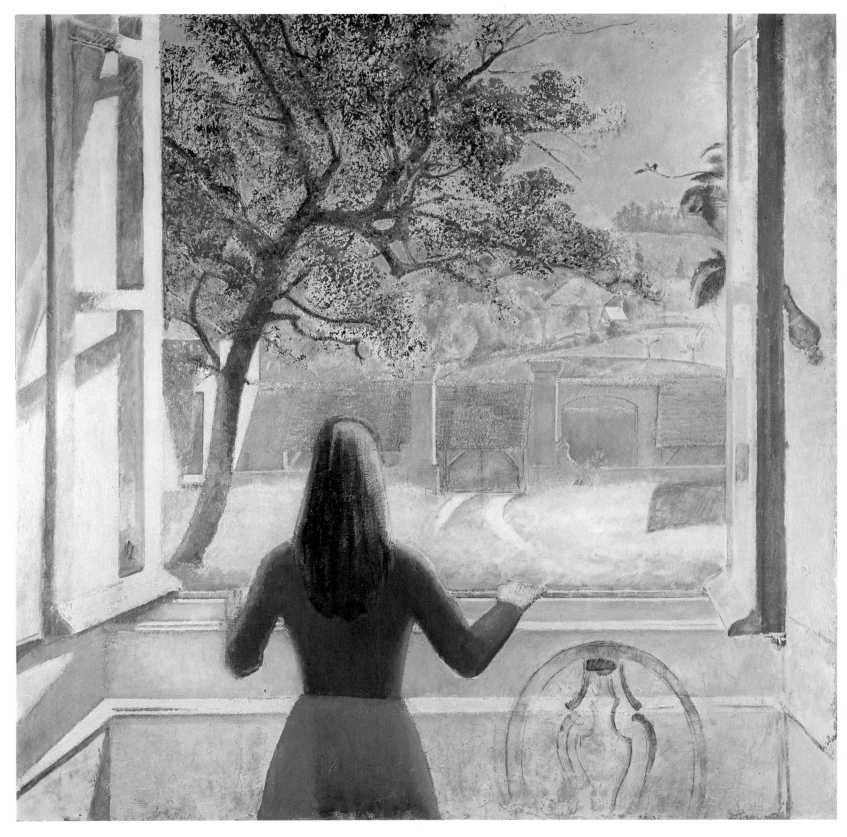

70 *Jeune fille à la fenêtre* 1957

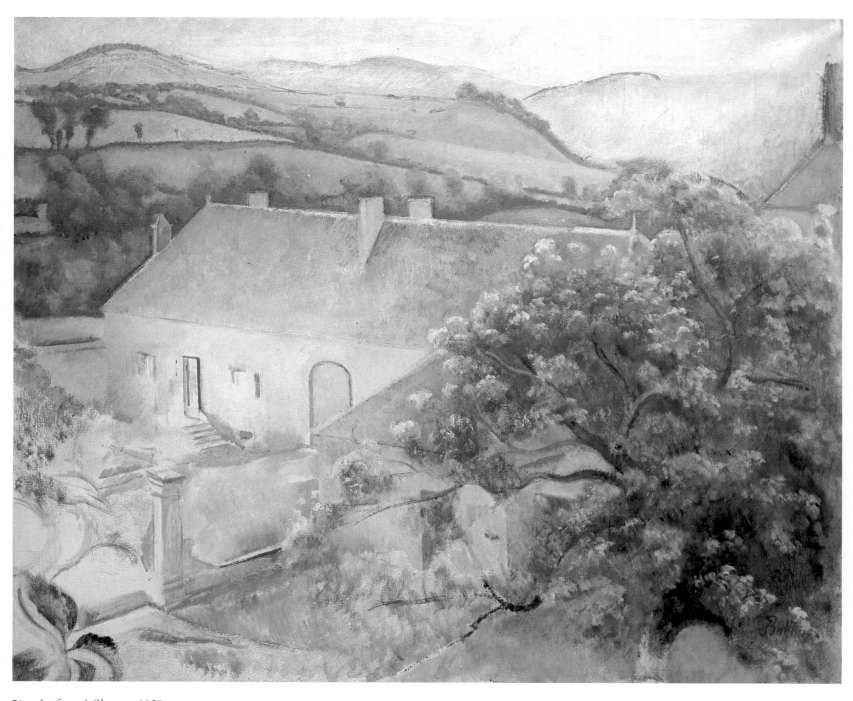

71 *La ferme à Chassy* 1958

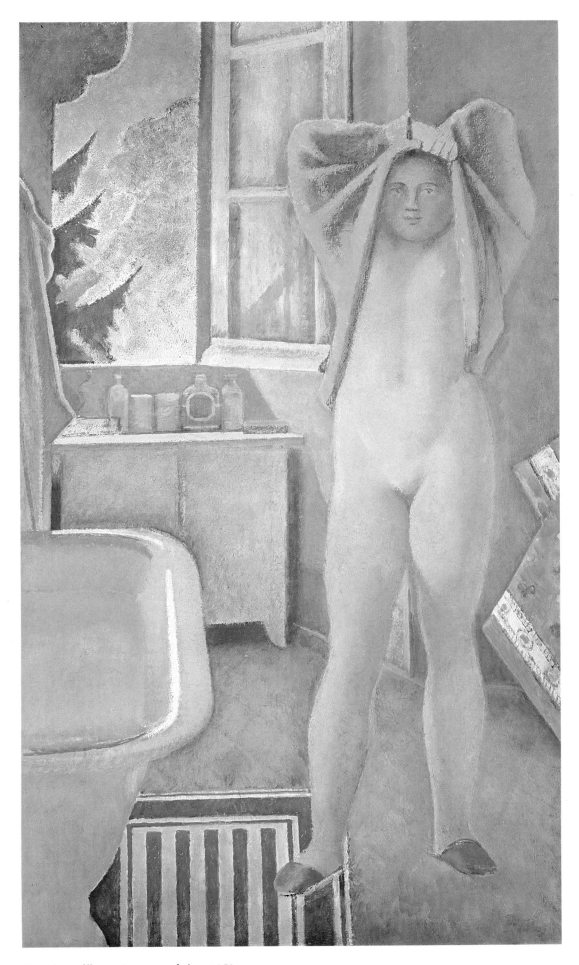

72 *Jeune fille se préparant au bain* 1958

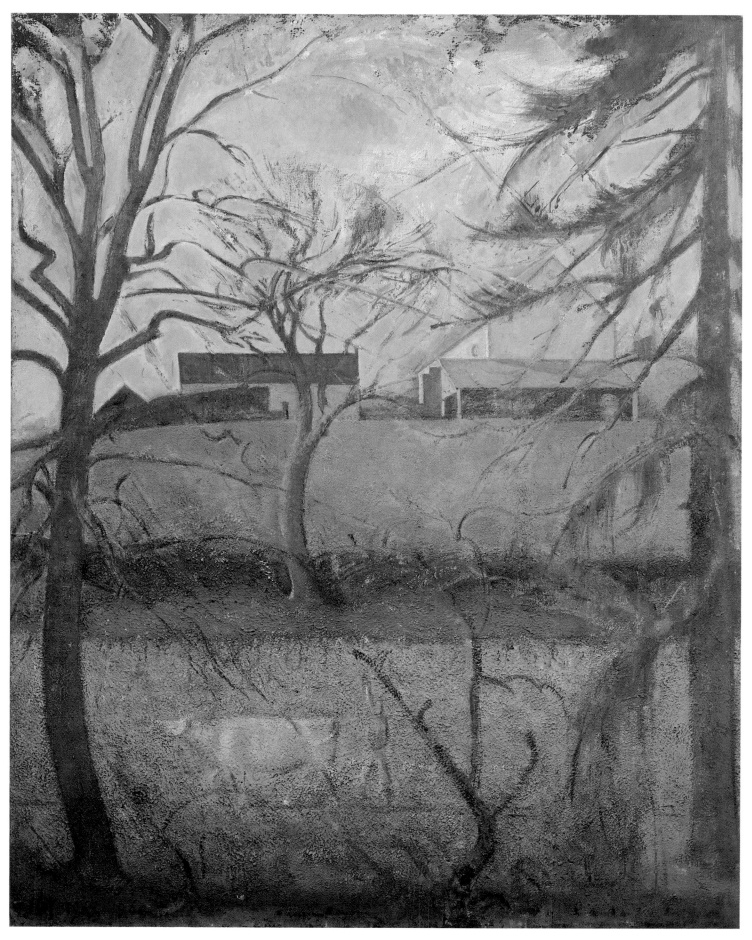

73 *Grand paysage avec vache* 1959–60

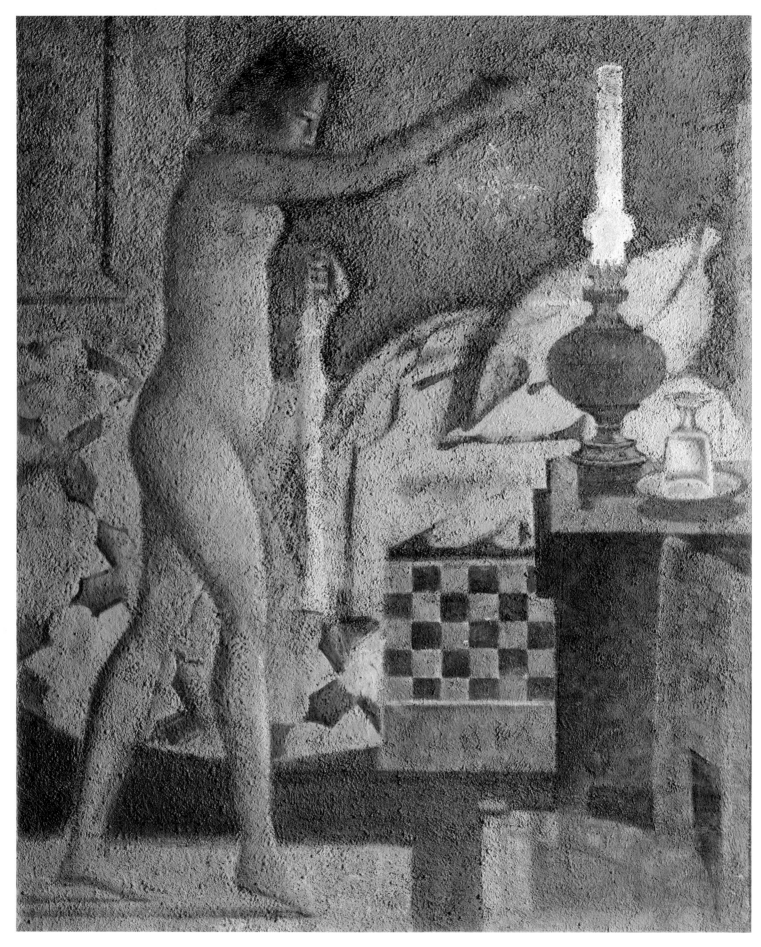

74 *Le phalène* 1959

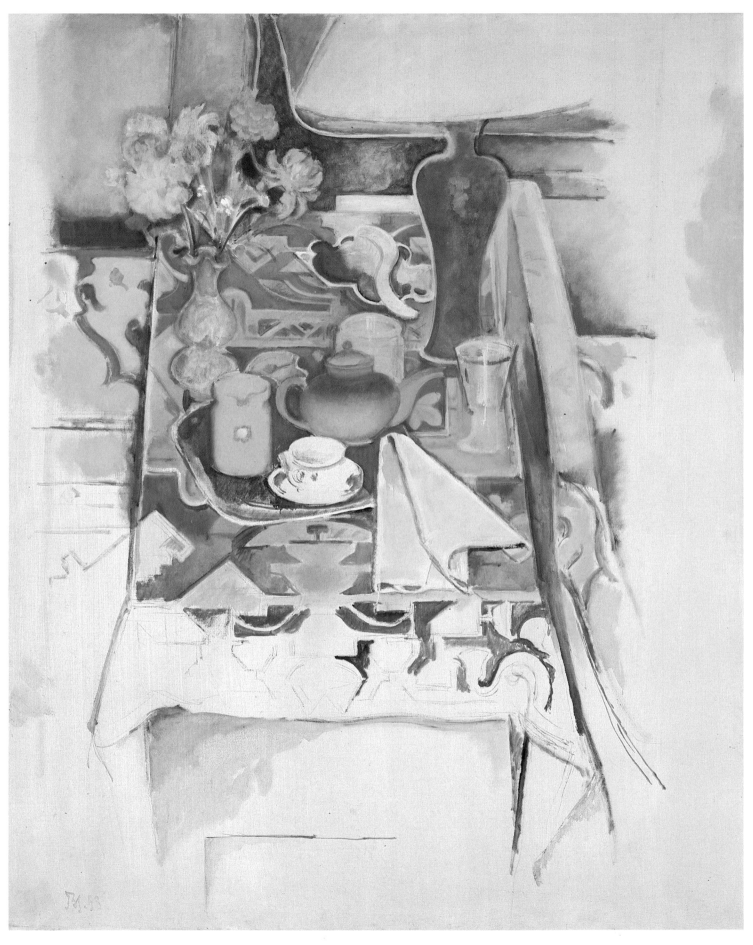

75 *Nature morte à la lampe* 1958

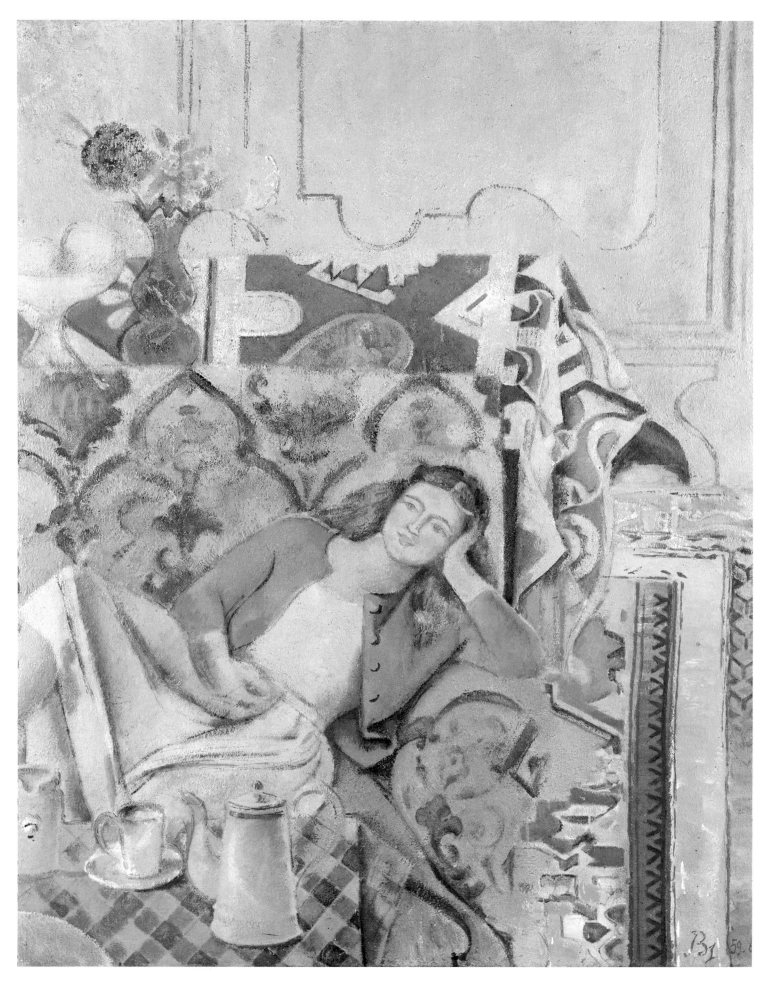

76 *La tasse de café* 1959–60

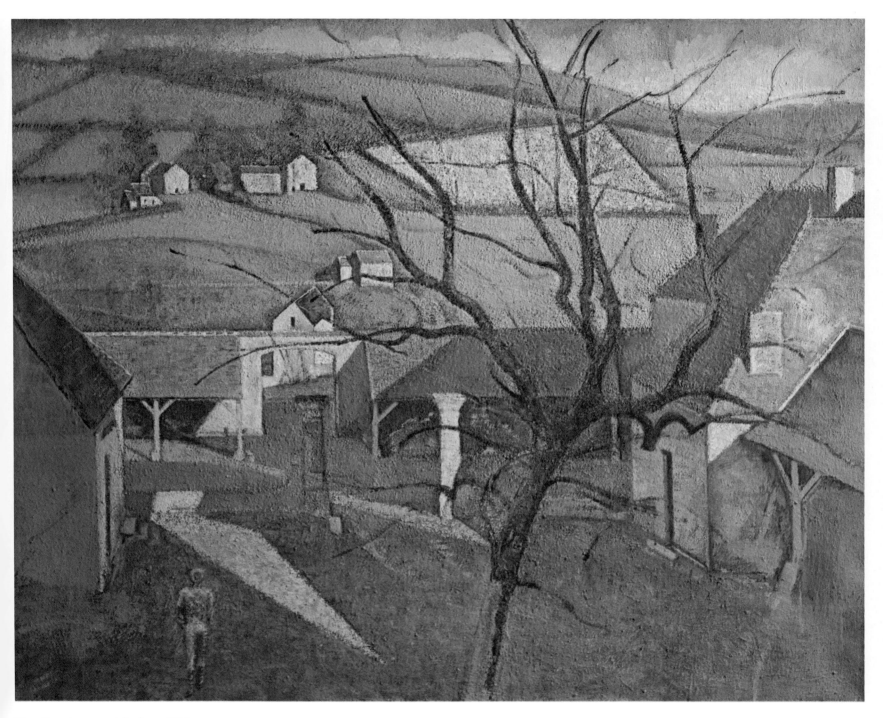

77 *Grand paysage à l'arbre* 1960

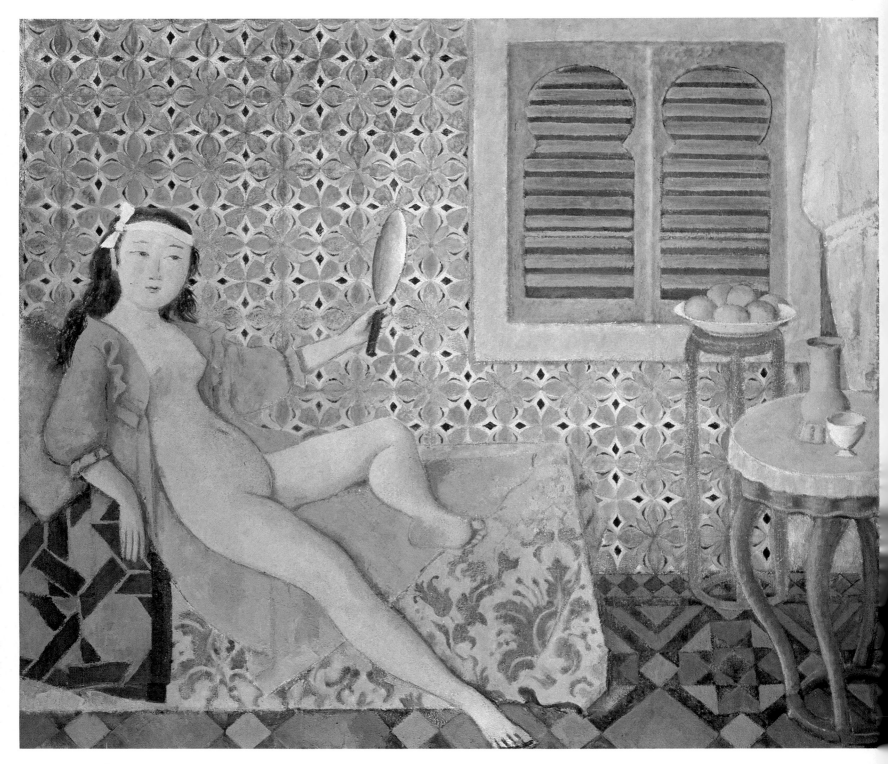

78, 79 *La chambre turque* 1963–66

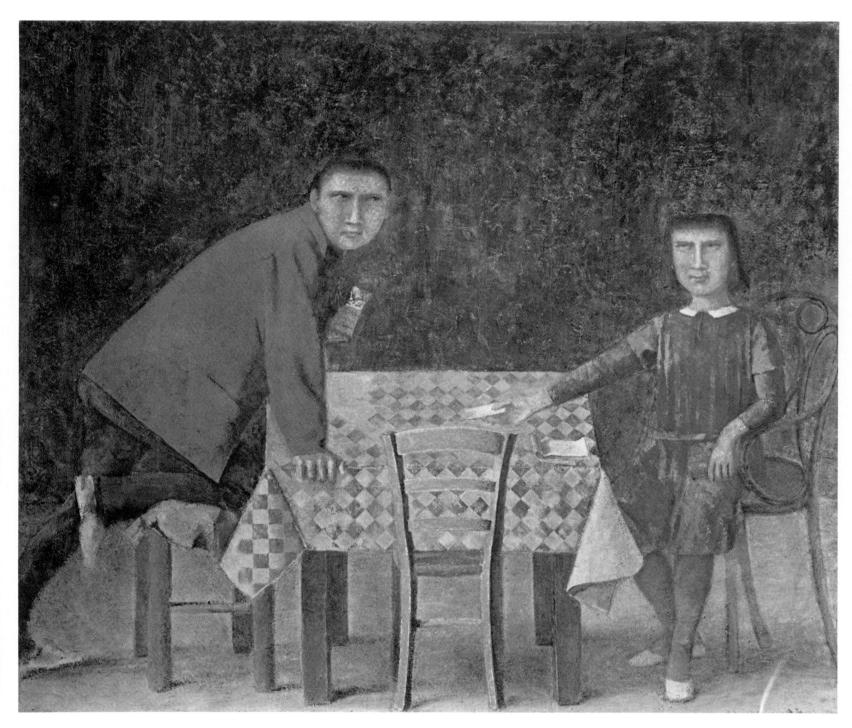

80 *Les joueurs de cartes* 1966–73

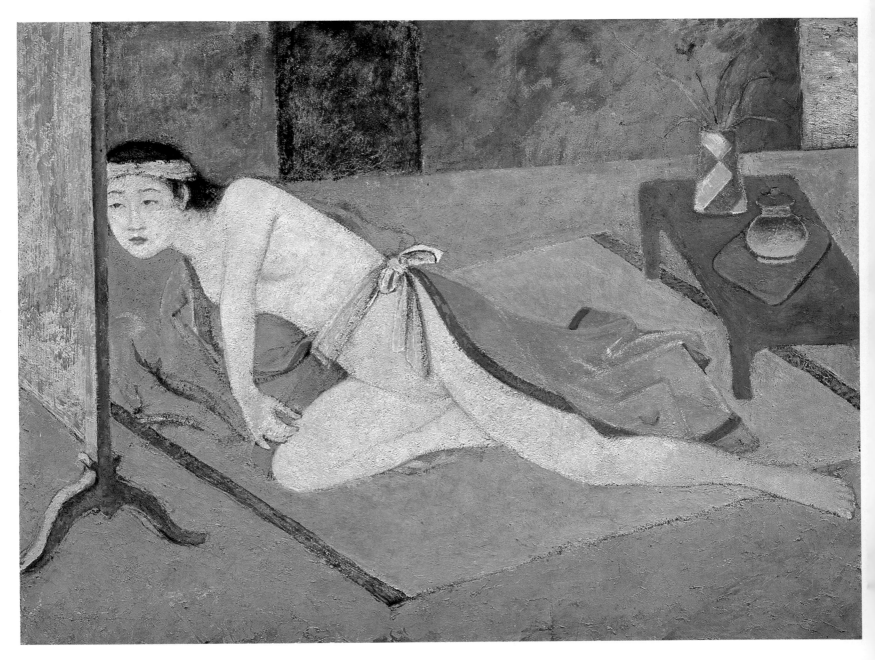

81, 82 *Japonaise à la table rouge* 1967–76

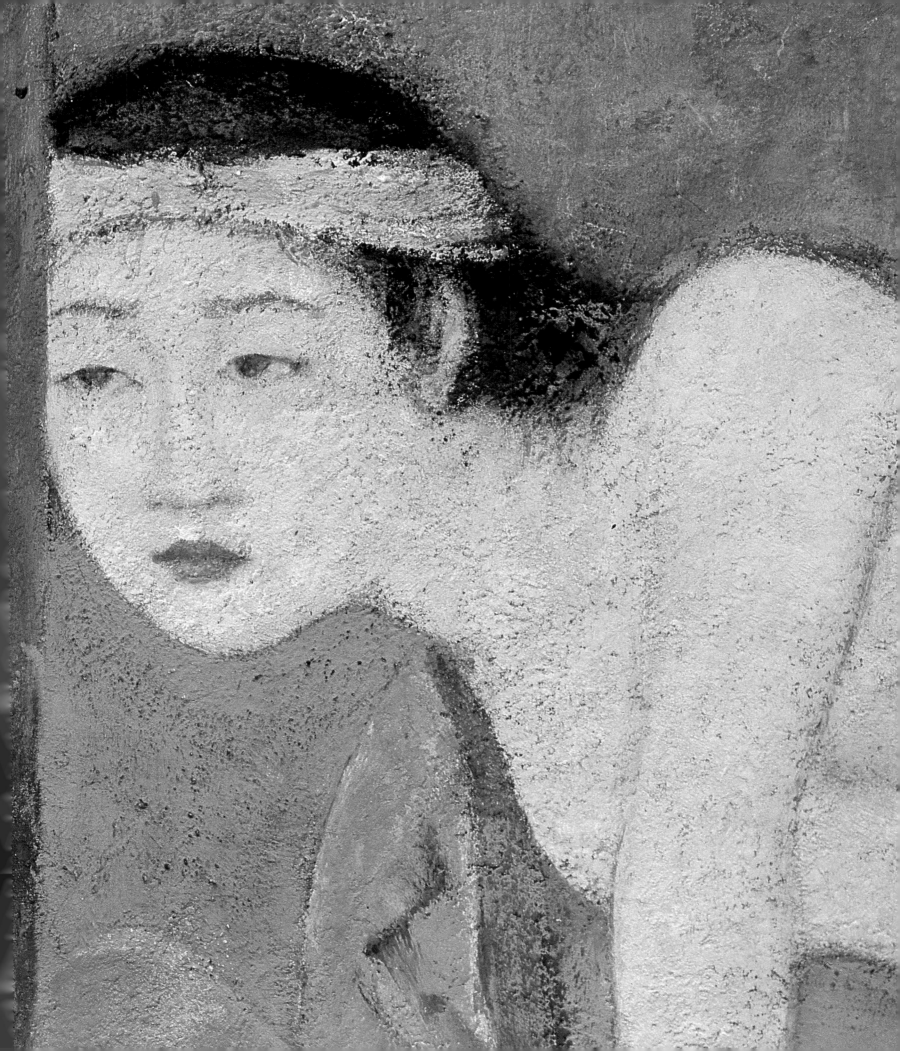

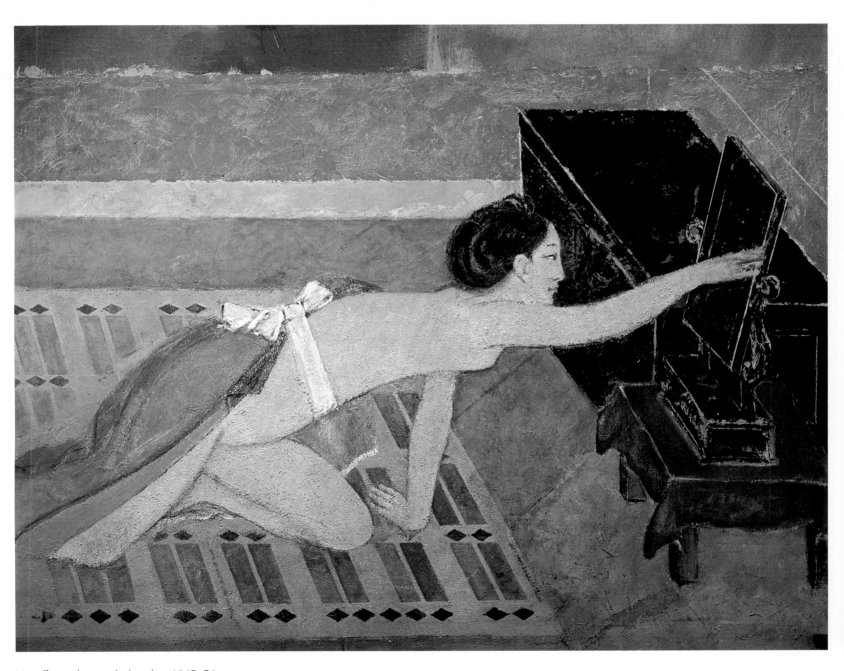

83 *Japonaise au miroir noir* 1967–76

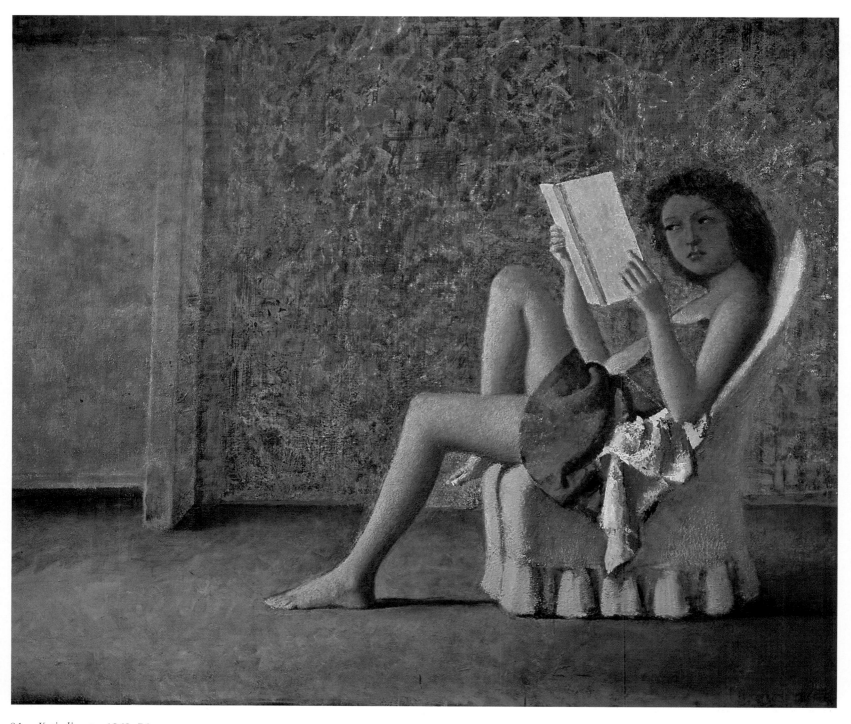

84 *Katia lisant* 1968–76

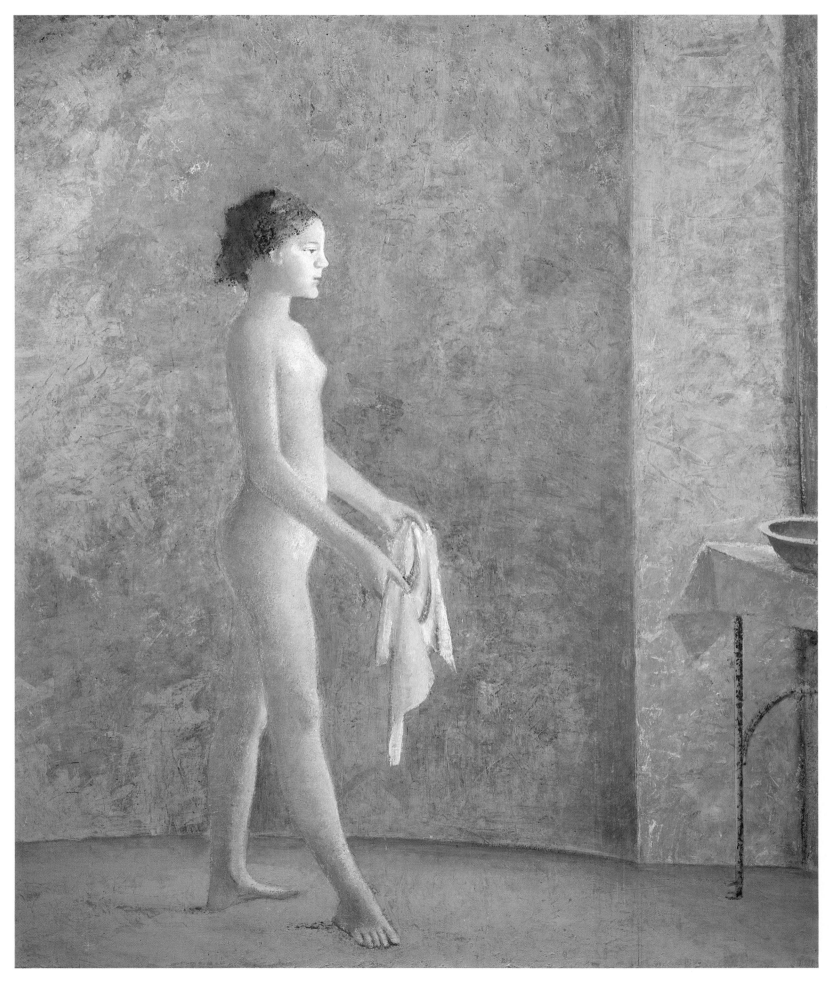

85 *Nu de profil* 1973–77

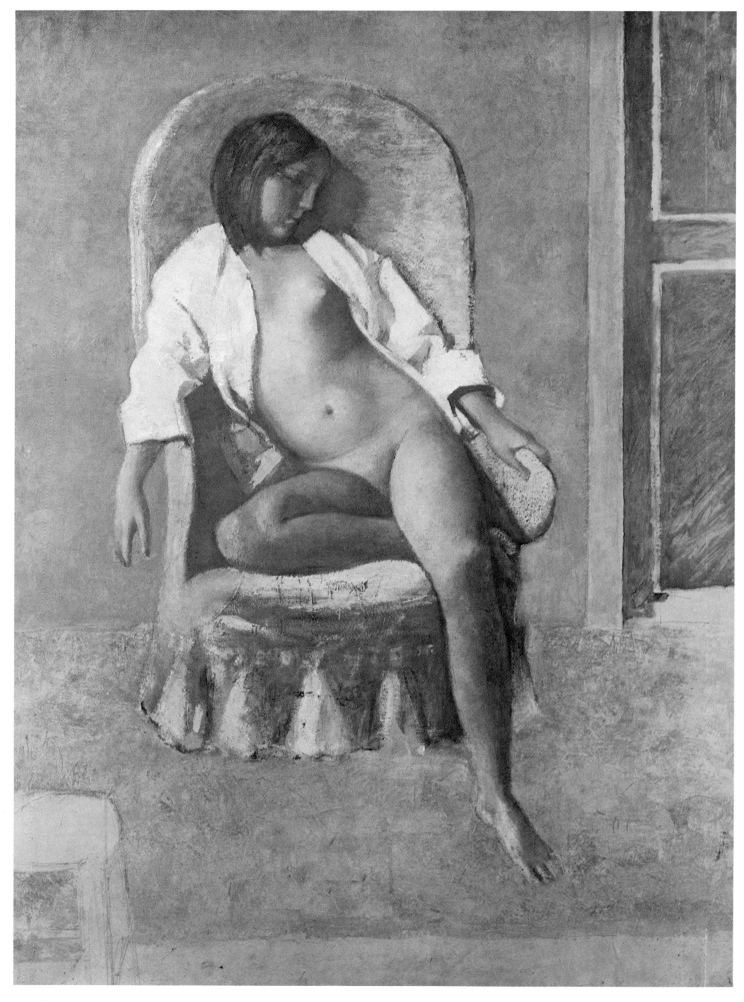

86 *Nu au repos* 1977

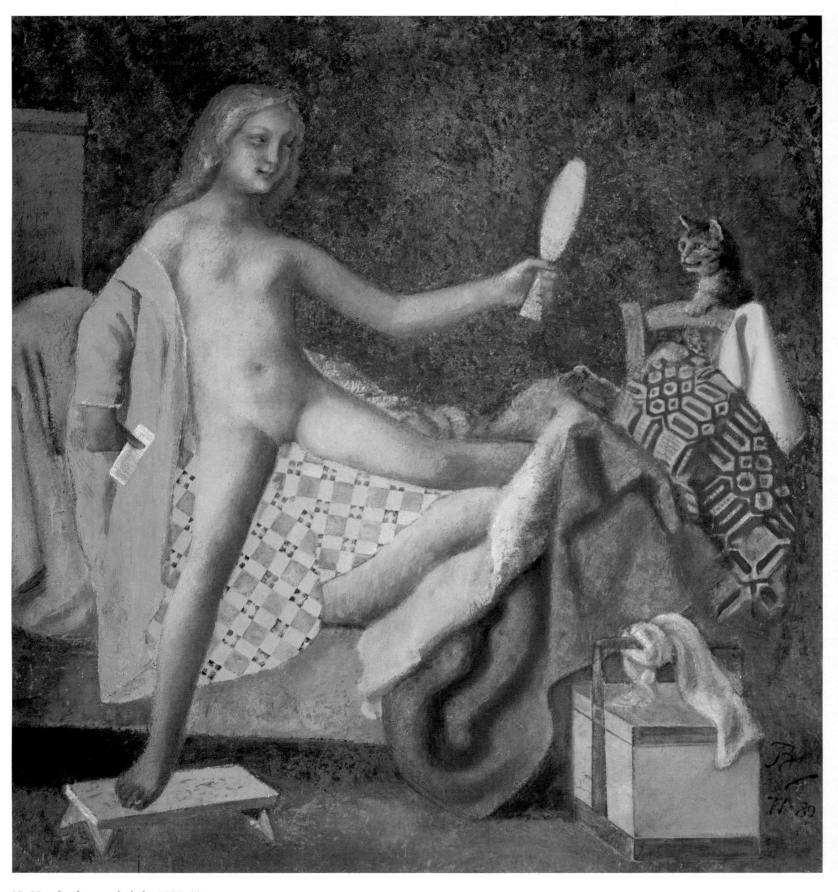

87, 88 *Le chat au miroir I* 1977–80

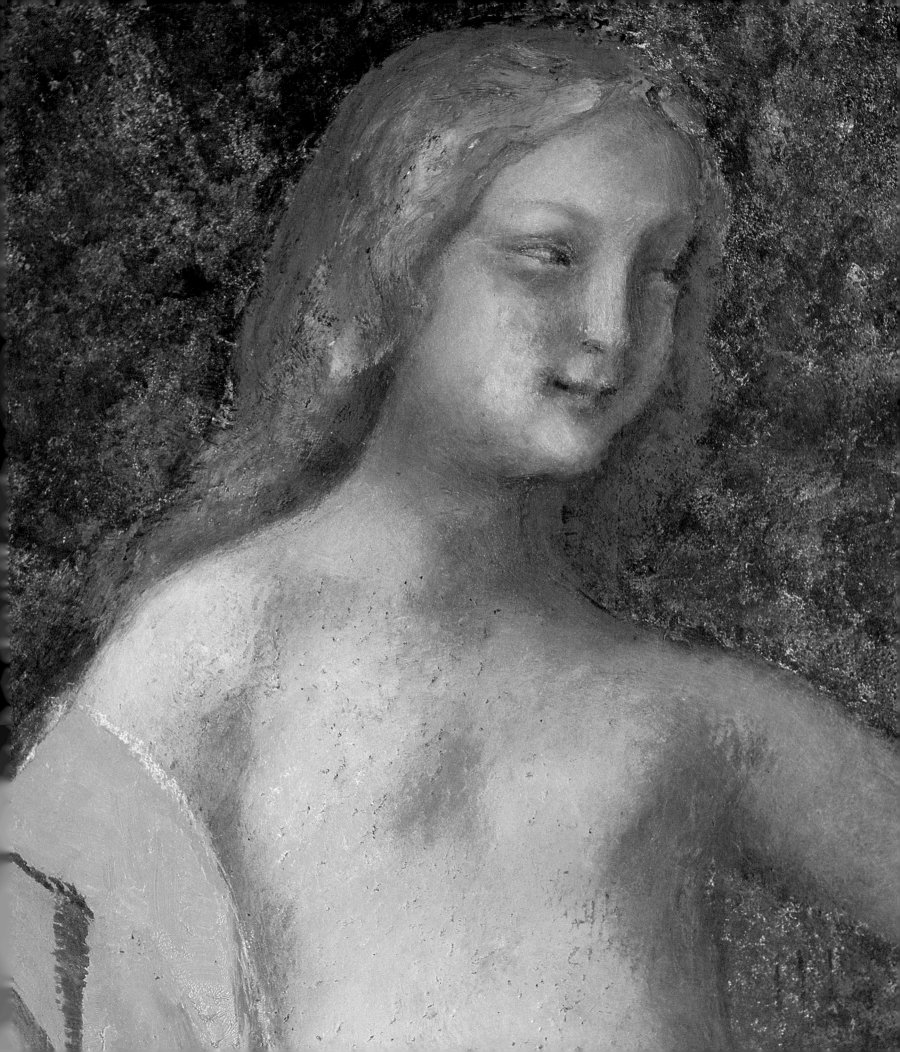

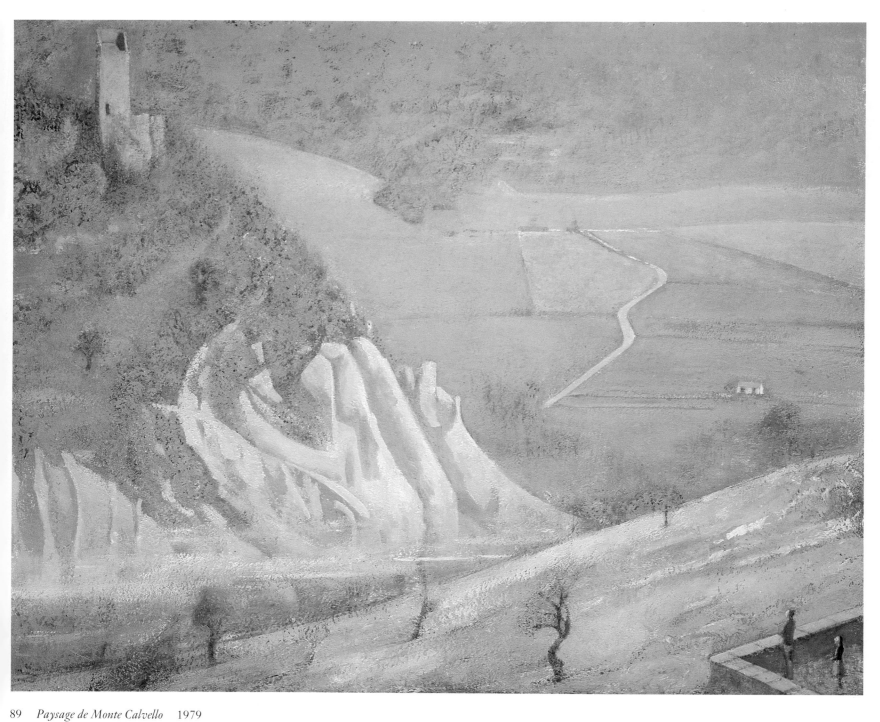

89 *Paysage de Monte Calvello* 1979

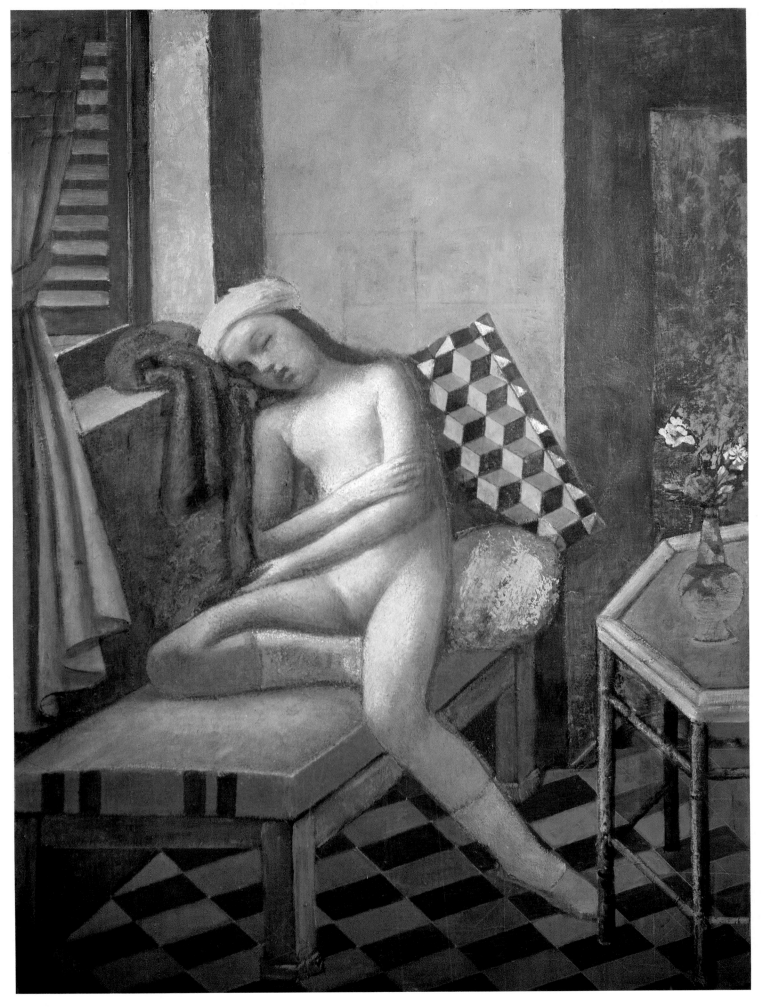

90, 91 *Nu assoupi* 1980

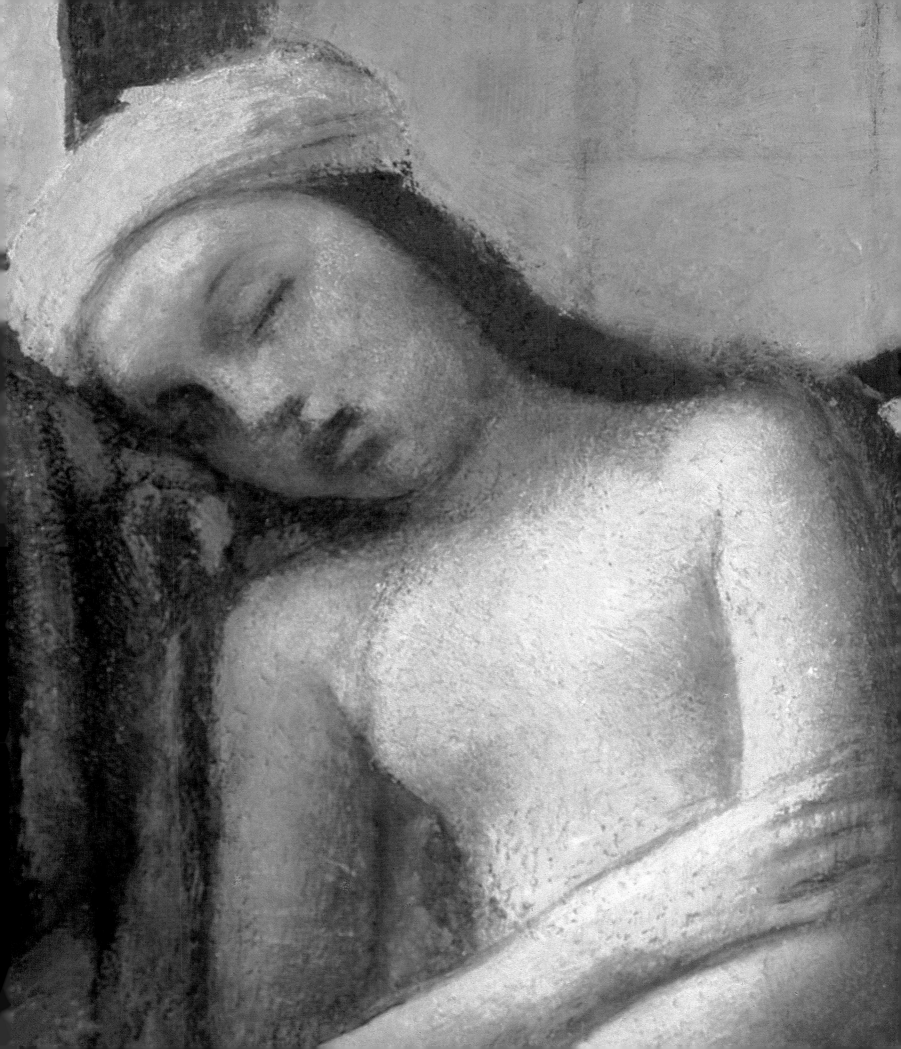

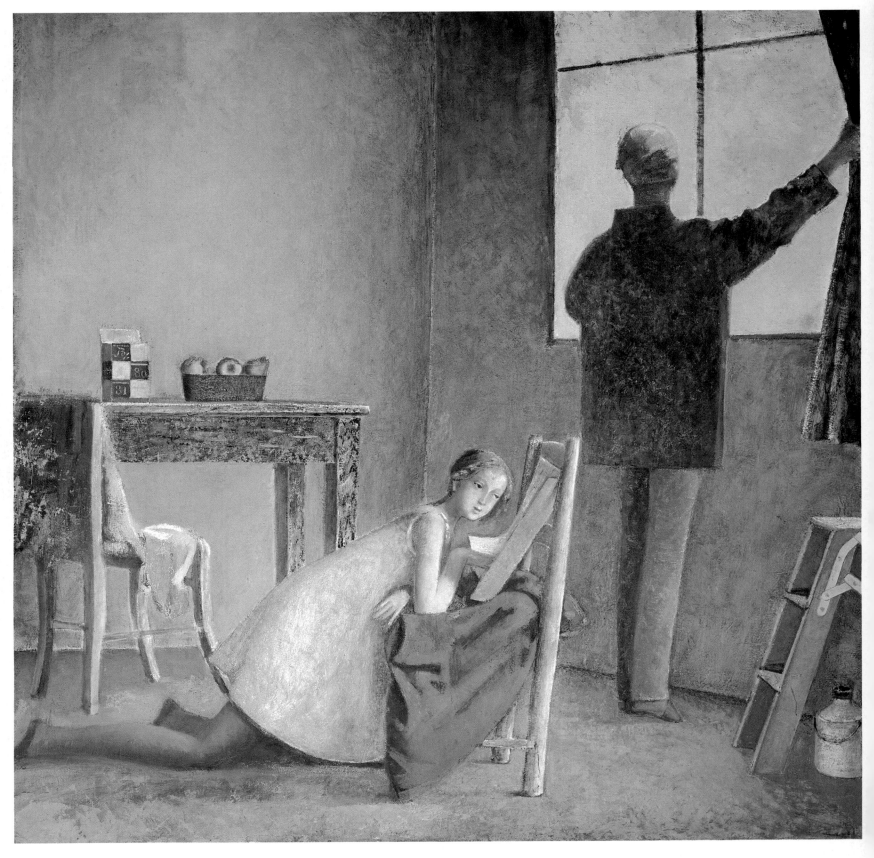

92, 93 *Le peintre et son modèle* 1980–81

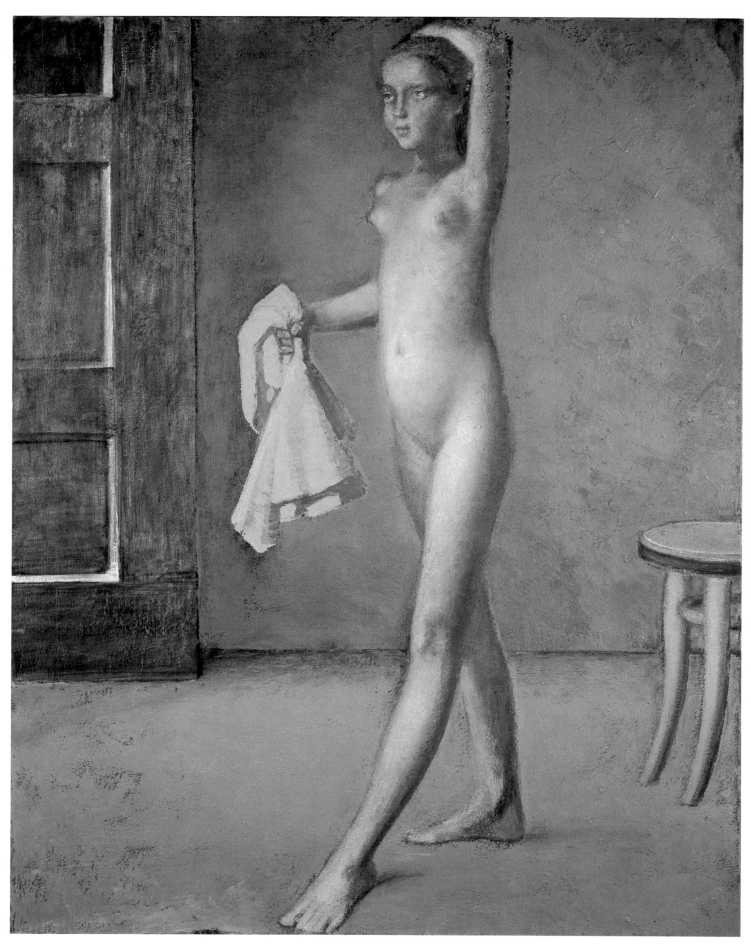

94 *Le drap bleu* 1981–82

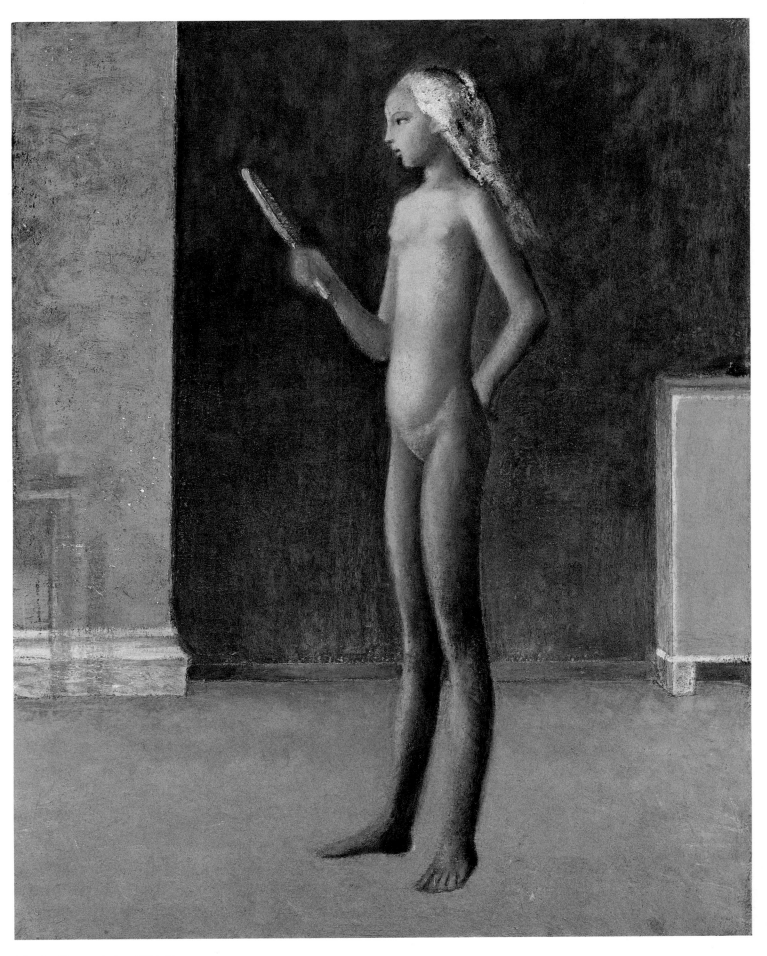

95, 96 *Nu au miroir* 1981–83

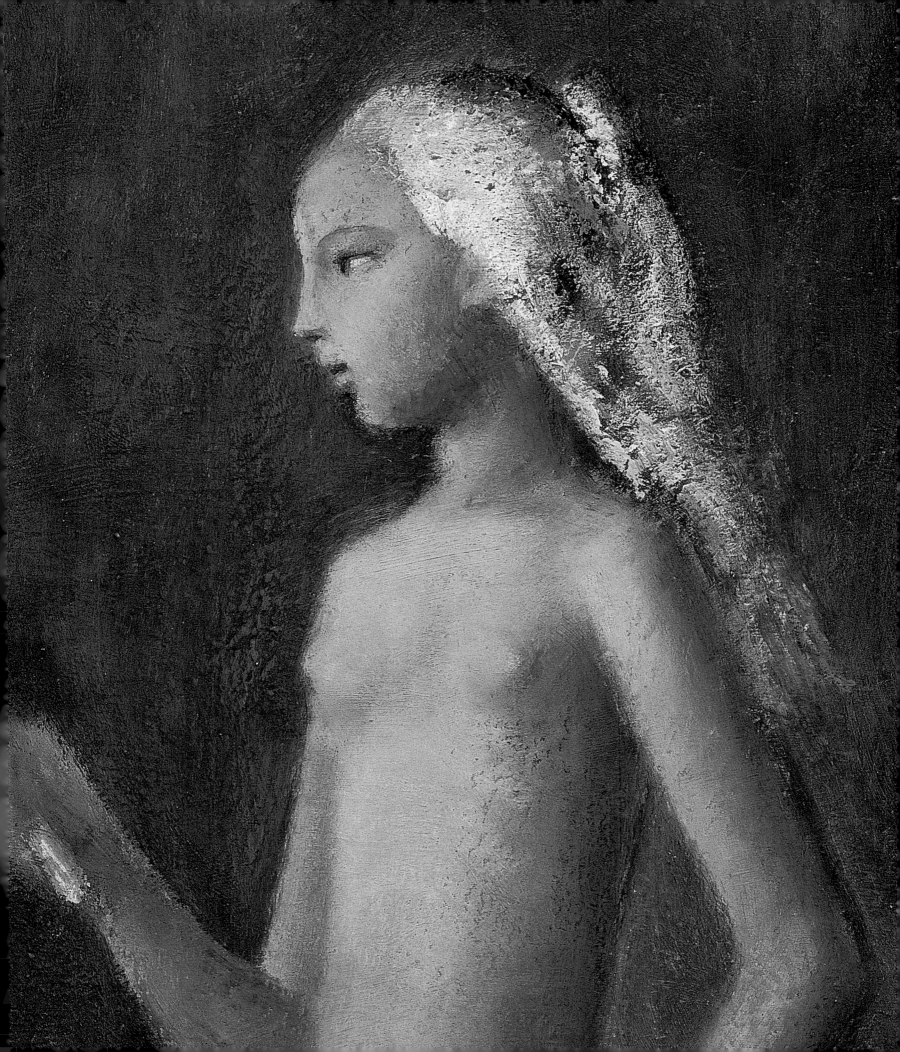

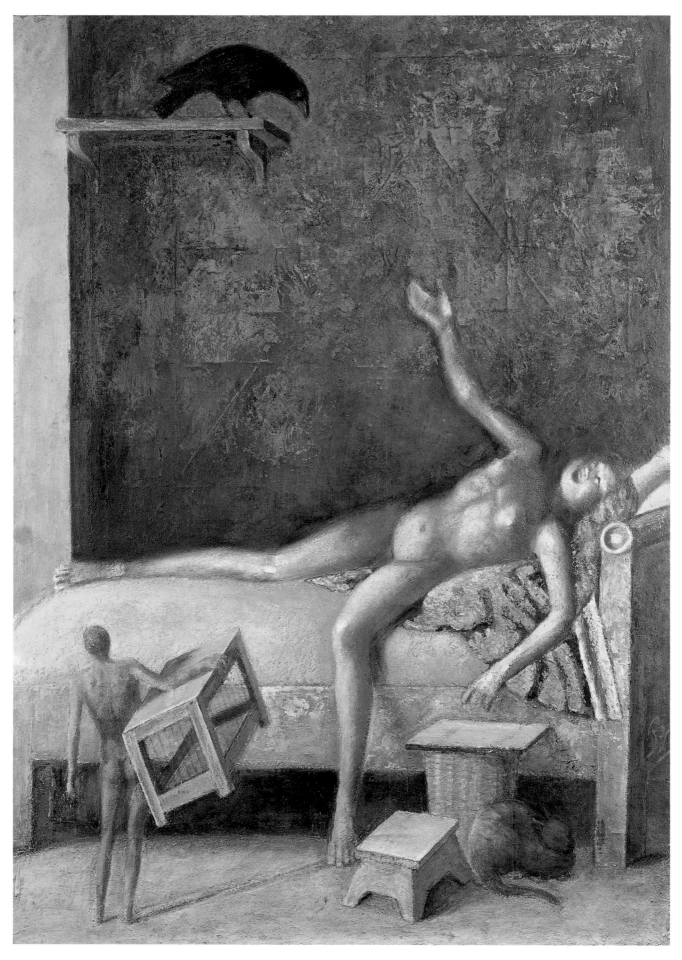

97 *Grande composition au corbeau* 1983–86

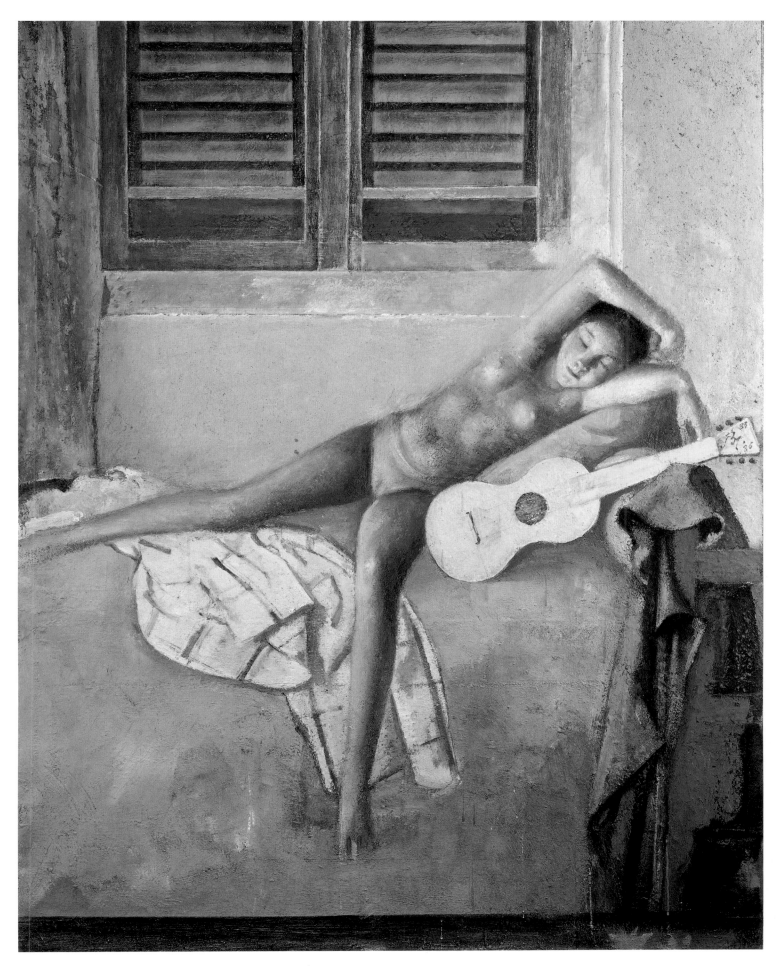

98, 100 *Nu à la guitare* 1983–86

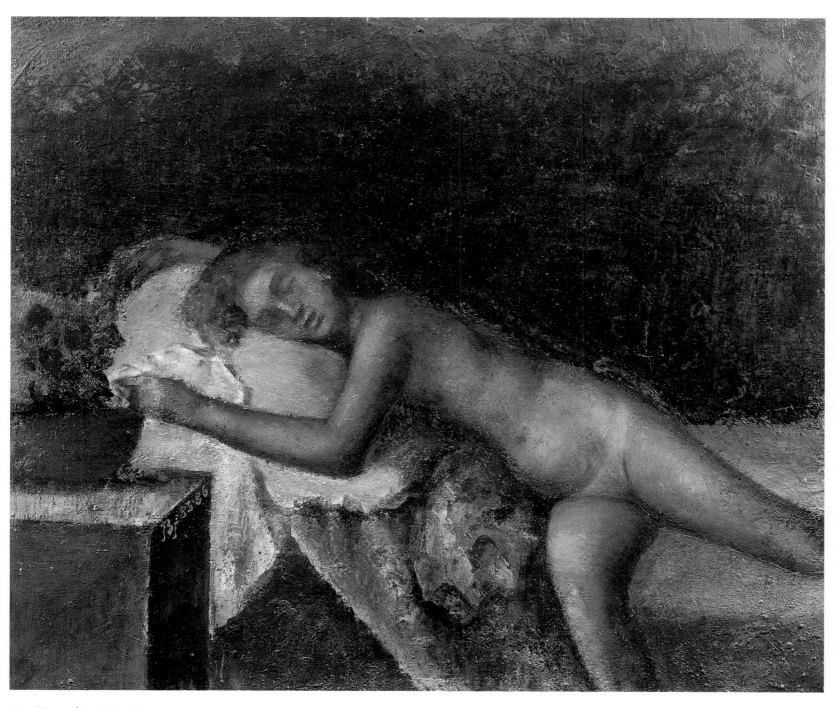

99 *Nu couché* 1983–86

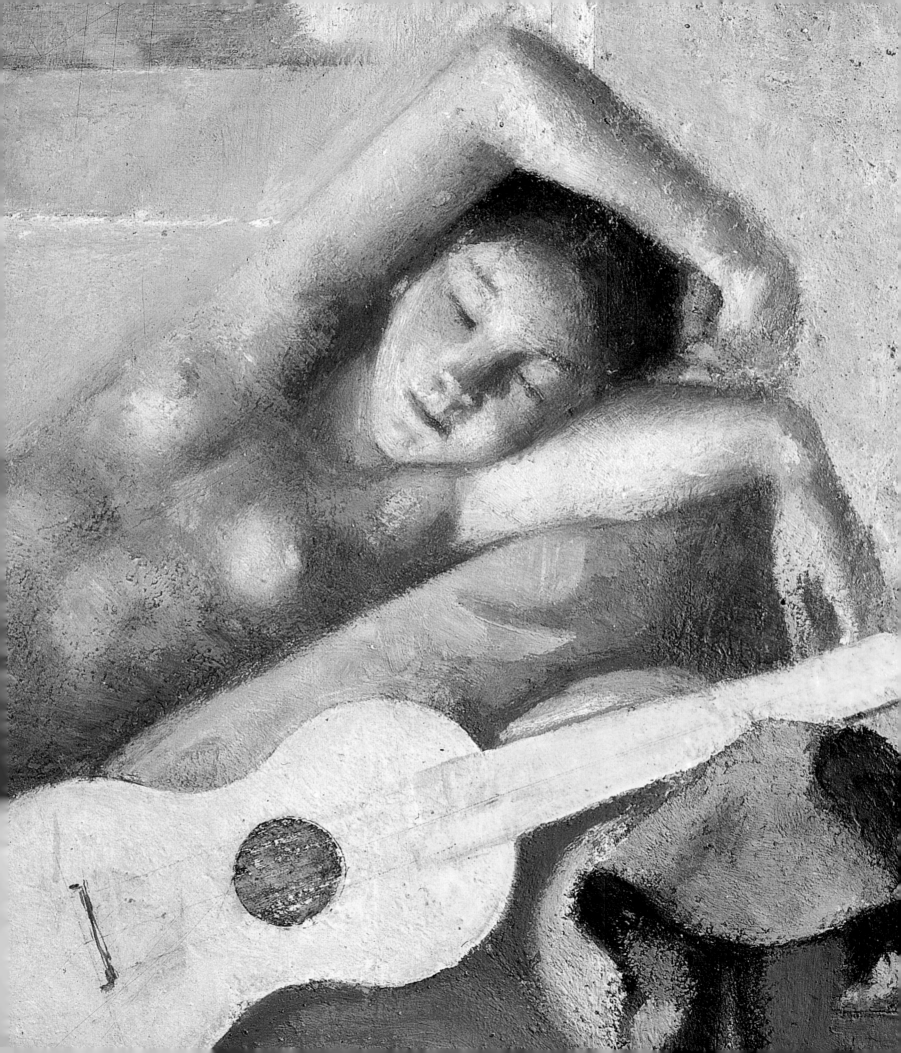

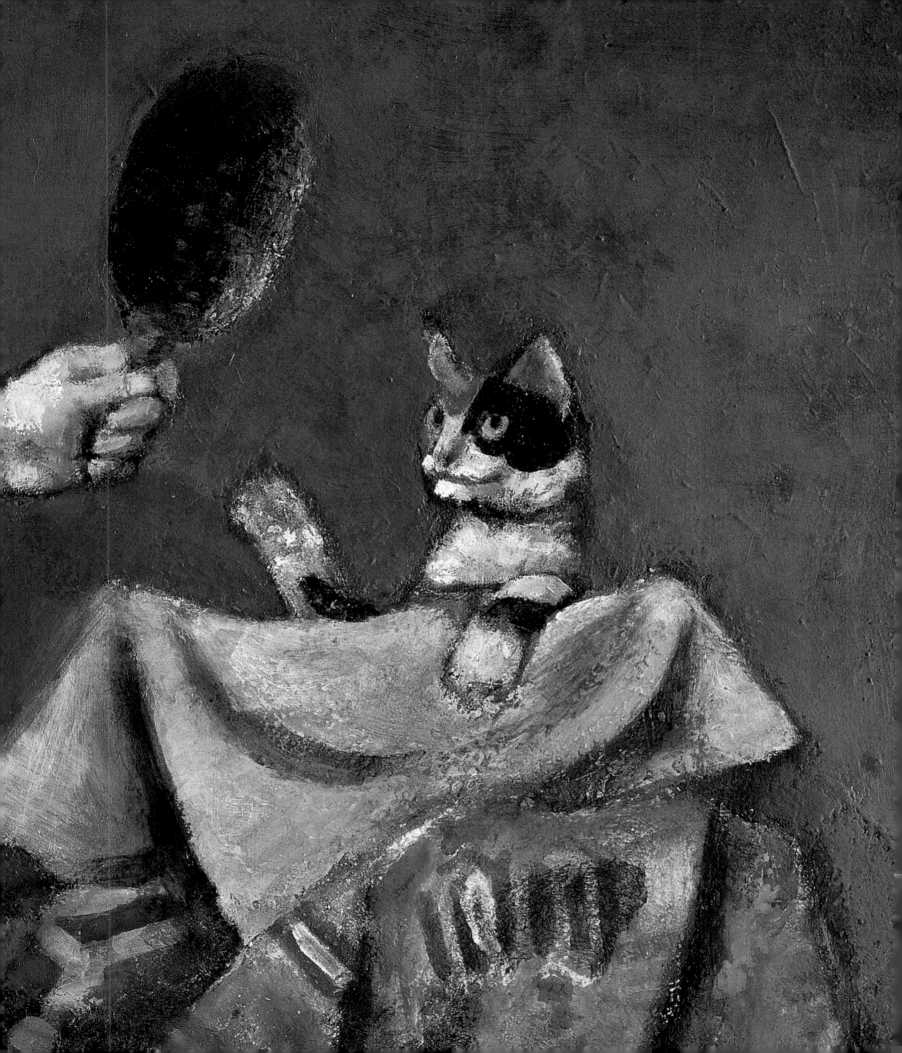

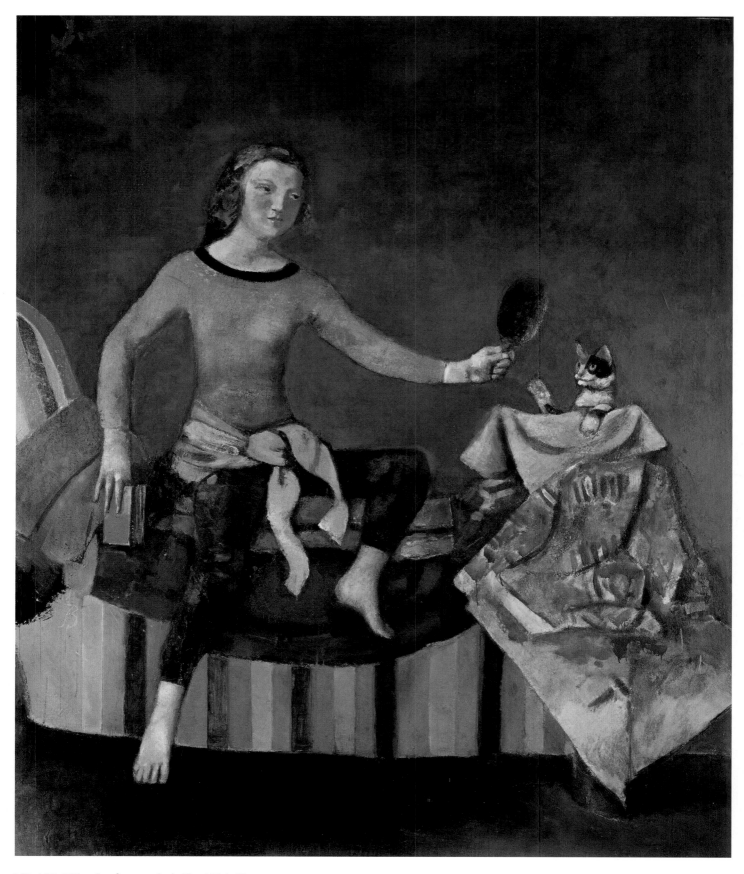

101, 102, 105 *Le chat au miroir II* 1986–89

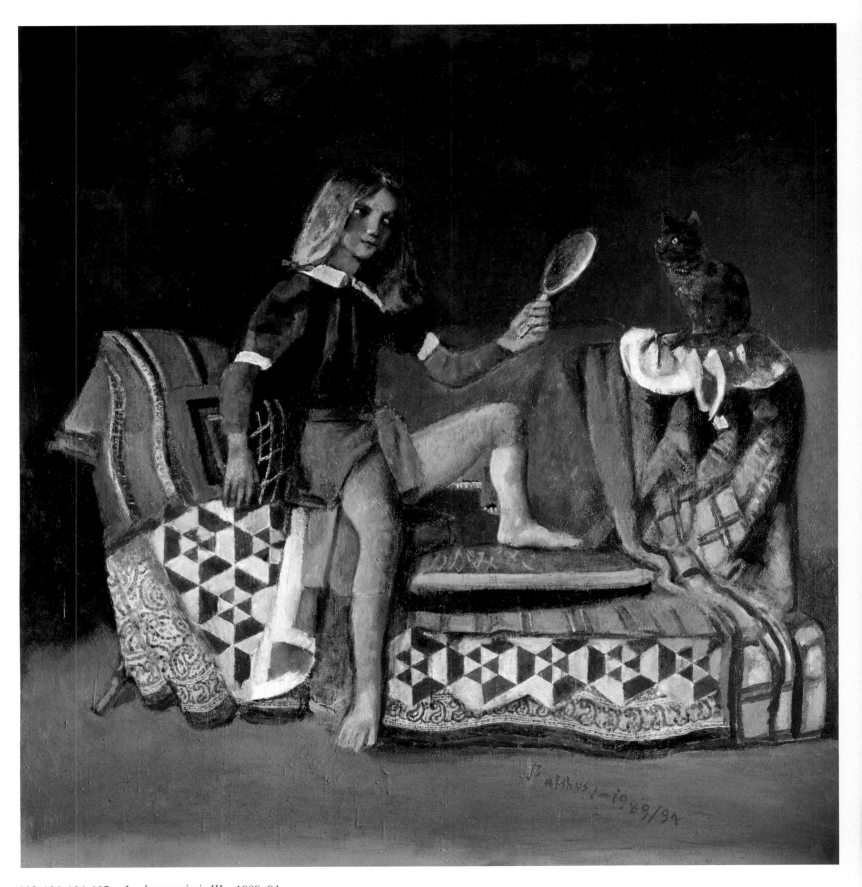

103, 104, 106, 107 *Le chat au miroir III* 1989–94

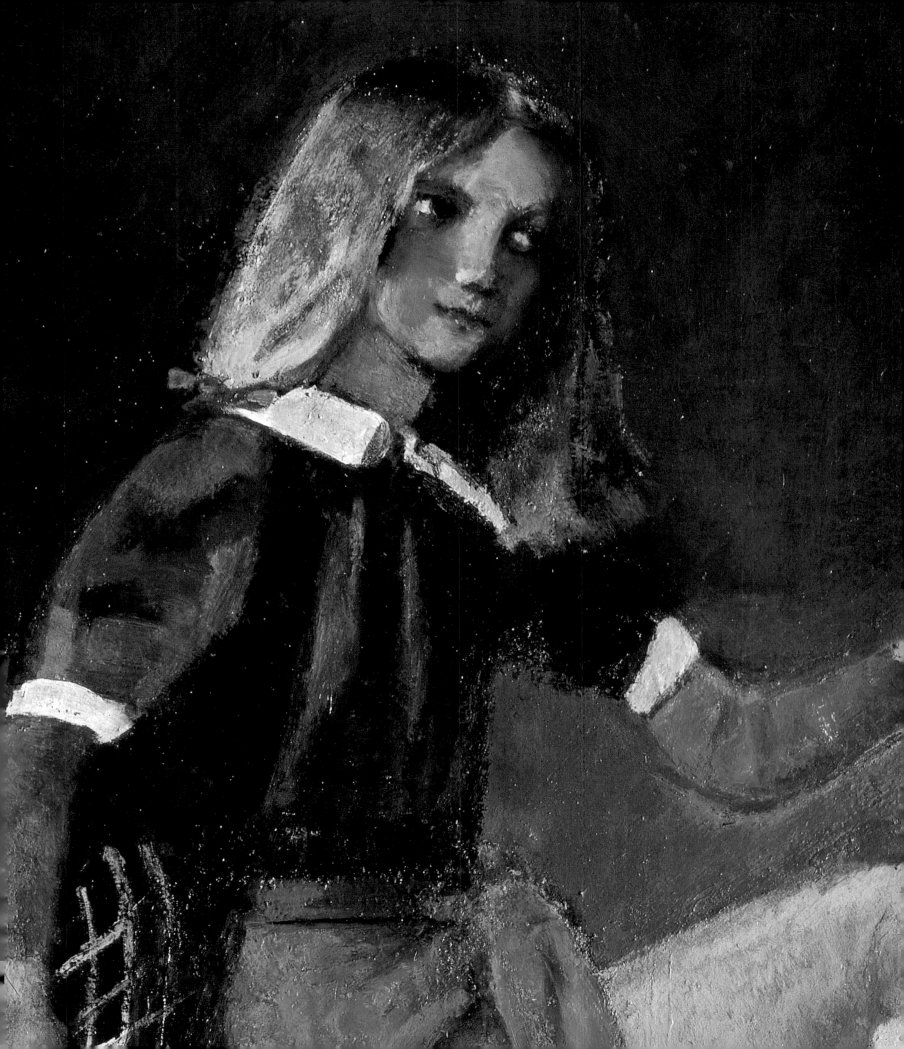

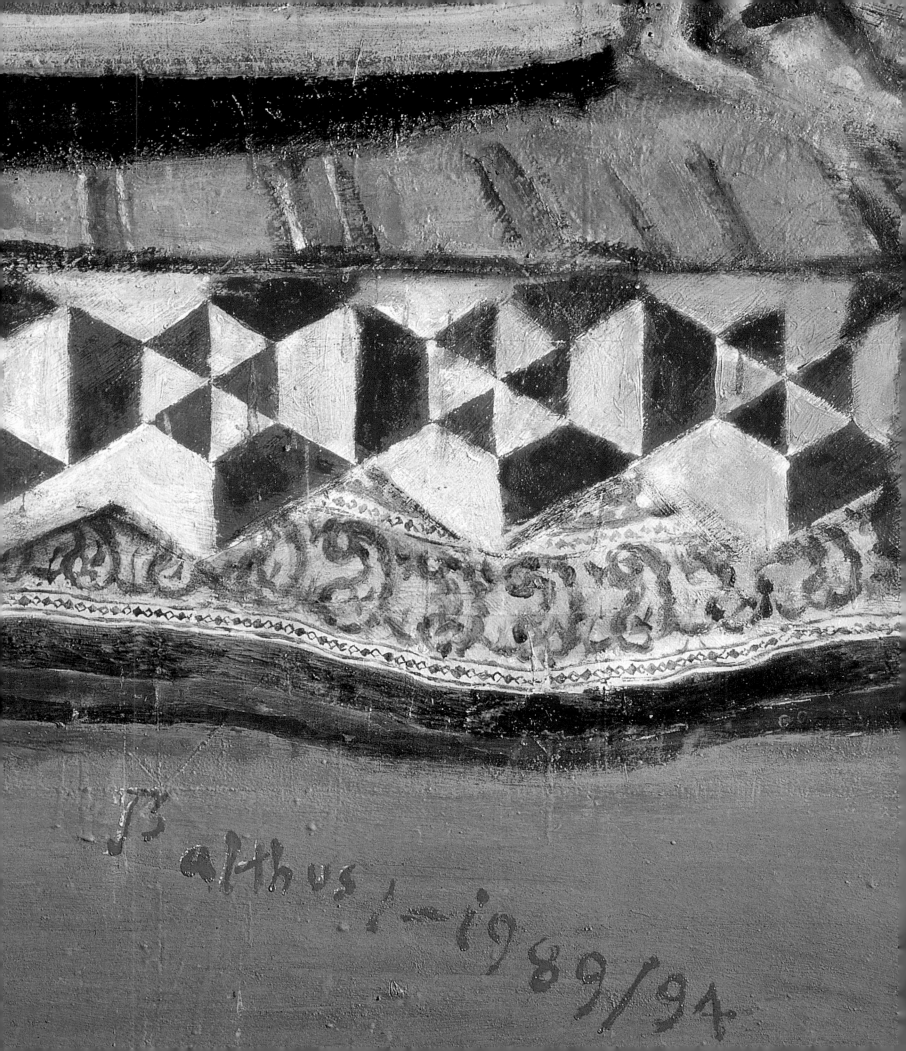

LIST OF WORKS

AND

BIOGRAPHICAL NOTES

Measurements are given in centimetres and inches, height before width; works are presented in roughly chronological order. Please also note that the practice of listing media such as 'casein tempera on canvas' instead of 'oil on canvas' is misleading, as it is one of several materials used in the preparations of the canvas. 'Oil on canvas' encompasses all such materials.

PHOTOGRAPHS

I
Portrait by Man Ray, 1933
(© TMR/ADAGP, Paris,
1996, Collection L. Treillard)

II
Outside Château de Chassy,
France, by Loomis Dean, 1956
(Time Life Magazine/© Time
Warner)

III–V
Balthus's studio at Villa Medici,
Rome, 1973, by Giorgio Soavi

VI, VII
At Le Grand Chalet, Switzerland,
1991, by Henri Cartier-Bresson

VIII
At Le Grand Chalet, Switzerland,
1994, by Martin Summers

PAINTINGS

1 *Autoportrait* (detail)
 Self-portrait
 1940
 Oil on canvas
 44 × 32 (17³/₈ × 12⁵/₈)
 Author's collection
 Photo Joel von Allmen

2 *Le Pont Neuf*
 c. 1927
 Oil on canvas
 Photo Toninelli, Rome, courtesy of
 the artist

3 *Café de l'Odéon*
 1928
 Oil on canvas
 100 × 79 (39³/₈ × 31)
 Private collection
 Photo Jacqueline Hyde

4 *Jardin du Luxembourg*
 1928
 Oil on canvas
 46 × 55 (18¹/₈ × 21⁵/₈)
 Private collection
 Photo G. Howald, Kirchlindach-
 Bern

5 *Les quais*
 (The Embankment)
 1929
 Oil on canvas
 71 × 58 (28¹/₂ × 23³/₄)
 Collection Pierre Matisse
 Photo Pierre Matisse Gallery

6 *La rue*
 (The Street)
 1929
 Oil on canvas
 129.5 × 162 (51 × 63³/₄)
 Private collection
 Photo Pierre Matisse Gallery

7 *La rue*
 (The Street)
 1933–35
 Oil on canvas
 195 × 240 (76³/₄ × 94¹/₂)
 Collection, The Museum of
 Modern Art, New York. James
 Thrall Soby Bequest

8 Detail of *La rue*

9 Detail of *La rue*

10 *Alice*
 1933
 Oil on canvas
 112 × 161 (44 × 63¹/₂)
 Private collection, Switzerland
 Photo Marlborough Fine Art
 (London) Ltd

11 *La toilette de Cathie*
 (Cathy Dressing)
 1933
 Oil on canvas
 65 × 59 (25⁵/₈ × 23¹/₄)
 Musée National d'Art Moderne,
 Centre Georges Pompidou, Paris
 Photo Jacqueline Hyde

12 *La famille Mouron-Cassandre*
 1935
 Oil on canvas
 72 × 72 (28³/₈ × 28³/₈)
 Private collection
 Photo Maurice Aeschimann

13 Detail of *La famille Mouron-
 Cassandre*

14 *Lelia Caetani*
 1935
 Oil on canvas
 116 × 88 (45¹/₂ × 34¹/₂)
 Private collection
 Photo Pierre Matisse
 Foundation

15 *La montagne*
 (The Mountain)
 1935–37
 Oil on canvas
 250 × 365.1 (98¹/₂ × 143³/₄)
 The Metropolitan Museum of Art,
 New York, Purchase, Gifts of Mr
 and Mrs Nate B. Springold and
 Nathan Cummings, Rogers Fund
 and The Alfred N. Punnett
 Endowment Fund, by exchange,
 and Harris Brisbane Dick Fund,
 1982
 Photo Pierre Matisse Gallery

16 Detail of *La montagne*

17 *André Derain*
 1936
 Oil on wood
 112.7 × 72.4 (44³/₈ × 28¹/₂)
 Collection, The Museum of
 Modern Art, New York. Acquired
 through the Lillie P. Bliss
 Bequest

18 *Thérèse*
1938
Oil on canvas
100.3 × 81.3 (39½ × 32)
Metropolitan Museum of Art,
gift of Mr and Mrs Allan D.
Emil in honour of William S.
Lieberman, 1987
Photo Pierre Matisse Gallery

19 *Portrait de Thérèse*
1936
Oil on canvas
62 × 71 (24½ × 28)
Private collection, Switzerland
Photo Marlborough Fine Art
(London) Ltd

20 *Portrait de la Vicomtesse de Noailles*
1936
Oil on canvas
135 × 160 (53¼ × 63)
Private collection
Photo Jacqueline Hyde

21 *Les enfants*
(The Children)
1937
Oil on canvas
125 × 130 (49¼ × 51⅛)
Musée du Louvre, Paris, donation
Pablo Picasso
Photo Musées Nationaux, Paris

22 *Jeune fille au chat*
(Girl with Cat)
1937
Oil on canvas
88 × 78 (31½ × 34⅝)
Collection Mr and Mrs E. A.
Bergman
Photo Pierre Matisse Gallery

23 *Nature morte*
(Still-life)
1937
Oil on wood panel
81 × 100 (31⅞ × 39⅜)
Wadsworth Atheneum, Hartford,
Connecticut. The Ella Gallup
Sumner and Mary Catlin Sumner
Collection 1938.272

24 *La jupe blanche*
(The White Skirt)
1937
Oil on canvas
130 × 162 (51⅛ × 63¾)
Private collection, Switzerland
Photo Borel-Boissonnas

25 *Portrait d'une jeune fille en costume
d'amazone*
*(Portrait of a Young Woman in Riding
Costume)*
1932, repainted 1981
Oil on canvas
72 × 52 (28⅜ × 20½)
Author's collection
Photo Joel von Allmen

26 Detail of *Portrait d'une jeune fille en
costume d'amazone*

27 *Joan Miró et sa fille Dolorès*
(Joan Miró and his Daughter Dolorès)
1937–38
Oil on canvas
130.2 × 88.9 (51¼ × 35)
The Museum of Modern Art, New
York. Abby Aldrich Rockefeller
Fund, 1938

28 *La victime*
(The Victim)
1938
Oil on canvas
133 × 220 (53⅖ × 86⅝)
Private collection
Photo Jacqueline Hyde

29 *Thérèse rêvant*
(Thérèse Dreaming)
1938
Oil on canvas
150.5 × 130.2 (59¼ × 51¼)
Private collection
Photo Pierre Matisse Gallery

30 Detail of *Autoportrait*

31 *Autoportrait*
Self-portrait
1940
Oil on canvas
44 × 32 (17⅜ × 12⅜)

Author's collection
Photo Joel von Allmen

32 *Larchant*
1939
Oil on canvas
130 × 162 (51 × 63¾)
Private collection
Photo courtesy Electa

33 *Le Gottéron*
1943
Oil on canvas
115 × 99.5 (45¼ × 39⅛)
Collection P. Y. Chichong, Tahiti

34 *Vernatel (Paysage aux boeufs)*
Vernatel (Landscape with oxen)
1941–42
Oil on canvas
72 × 100 (28¾ × 39⅜)
Private collection

35 *Le cerisier*
(The Cherry Tree)
1940
Oil on canvas
92 × 73 (36¼ × 28¾)
Collection Mr and Mrs Henry
Luce III
Photo Galerie Claude Bernard

36 *Jeune fille et nature morte*
(Still-life with Girl)
1942
Oil on wood
73 × 92 (28¾ × 36¼)
Private collection
Photo Jacqueline Hyde

37 *Le salon*
(The Drawing-room)
1942
Oil on canvas
114.3 × 146 (45 × 57½)
Museum of Modern Art, New York,
Estate of John Hay Whitney

38 *Paysage de Champrovent*
(Landscape at Champrovent)
1942–45
Oil on canvas
98 × 130 (38½ × 51⅛)

Private collection
Photo Pierre Matisse Gallery

39 Detail of *Paysage de Champrovent*

40 *La jeune fille endormie*
 (Sleeping Girl)
 1943
 Oil on board
 79.7 × 98.5 (31³/₈ × 38⁵/₈)
 The Tate Gallery, London
 Photo John Webb

41 *La patience*
 (The Game of Patience, or Solitaire)
 1943
 Oil on canvas
 161 × 163.8 (63³/₈ × 64¹/₂)
 The Art Institute of Chicago, The
 Joseph Winterbotham Collection

42 *Jeune fille en vert et rouge*
 (Girl in Green and Red)
 1944
 Oil on canvas
 92 × 90.5 (36¹/₄ × 35⁵/₈)
 Collection, The Museum of
 Modern Art, New York. Helen
 Acheson Bequest

43 *L'écuyère*
 (Girl on a White Horse)
 1944
 Oil on cardboard
 80 × 90 (31¹/₂ × 35¹/₂)

44 *La princesse Maria Volkonski à l'âge de*
 douze ans
 (Princess Maria Volkonski at the age
 of twelve)
 1945
 Oil on canvas
 82 × 65 (32¹/₄ × 25³/₈)
 Countess Setsuko Klossowska de
 Rola, Switzerland
 Photo Joel von Allmen

45 Detail of *La princesse Maria*
 Volkonski à l'âge de douze ans

46 *Le chat de La Méditerranée*
 1949
 Oil on canvas

127 × 185 (50 × 73)
Private collection
Photo Jacqueline Hyde

47 *Les beaux jours*
 (Golden Days)
 1944–45
 Oil on canvas
 148 × 200 (58¹/₄ × 78¹/₄)
 The Hirshhorn Museum and
 Sculpture Garden, Smithsonian
 Institution, Washington DC

48 *Jeune fille à sa toilette*
 (Young Girl Dressing)
 1949–51
 Oil on canvas
 139 × 80.5 (54¹/₂ × 31)
 Collection Marina Picasso

49 *La toilette de Georgette*
 (Georgette Dressing)
 1948–49
 Oil on canvas
 95.9 × 92 (37³/₄ × 36¹/₄)
 The Elkon Gallery, Inc,
 New York

50 *Nu allongé*
 (Sleeping Nude)
 1950
 Oil on canvas
 133 × 220 (52¹/₂ × 86¹/₂)
 Private collection
 Photo Jacqueline Hyde

51 *Nu aux bras levés*
 (Nude with Arms Raised)
 1951
 Oil on canvas
 150 × 82 (59 × 32¹/₄)
 Private collection
 Photo Eileen Tweedy

52 *La partie de cartes*
 (The Card Game)
 1948–50
 Oil on canvas
 140 × 194 (55 × 76³/₈)
 Collection Thyssen-Bornemisza,
 Madrid

53 *Nu jouant avec un chat*
 (Nude Playing with a Cat)
 1949
 Oil on canvas
 65.1 × 80.5 (25¹/₂ × 31¹/₂)
 National Gallery of Victoria,
 Melbourne. Felton Bequest 1952

54 *La chambre*
 (The Room)
 1952–54
 Oil on canvas
 270 × 330 (106 × 130)
 Private collection
 Photo courtesy Electa

55 Detail of *La chambre*

56 *Le passage du Commerce*
 Saint-André
 1952–54
 Oil on canvas
 294 × 330 (115³/₄ × 130)
 Private collection
 Photo courtesy Electa

57 Detail of *Le passage du Commerce*
 Saint-André

58 *Jeune fille à la chemise blanche*
 (Girl in White)
 1955
 Oil on canvas
 116 × 89 (45³/₄ × 35)
 Private collection
 Photo Pierre Matisse Gallery

59 *Frédérique*
 1955
 Oil on canvas
 80.5 × 64.5 (31⁵/₈ × 25³/₈)
 Private collection
 Photo Jacqueline Hyde

60 *Jeune fille à la fenêtre*
 (Girl Leaning on a Windowsill)
 1955
 Oil on canvas
 196 × 130 (77 × 51)
 Private collection
 Photo Galerie Henriette
 Gomès

61 *Grand paysage aux arbres*
 (Le champ triangulaire)
 (Large Landscape with Trees
 [The Triangular Field])
 1955
 Oil on canvas
 114 × 162 (44³/₄ × 63³/₄)
 Private collection
 Photo Jacqueline Hyde

62 *La patience*
 (The Game of Patience, or
 Solitaire)
 1954–55
 Oil on canvas
 88 × 86 (34¹/₂ × 33³/₄)
 Private collection
 Photo Jacqueline Hyde

63 *Nu devant la cheminée*
 (Nude in Front of Mantel)
 1955
 Oil on canvas
 190.5 × 163.8 (75 × 64¹/₂)
 Metropolitan Museum of Art,
 New York. Robert Lehman
 Collection, 1975

64 *Jeune fille endormie*
 (Girl Asleep)
 1955
 Oil on canvas
 115.9 × 88.5 (45⁵/₈ × 34⁷/₈)
 Philadelphia Museum of Art:
 The Albert M. Greenfield and
 Elizabeth M. Greenfield
 Collection

65 *Golden Afternoon*
 1957
 Oil on canvas
 198.5 × 198.5 (78 × 78)
 Private collection
 Photo courtesy Electa

66 *Nature morte*
 (Still-life with Cherries)
 c. 1956
 Oil on canvas
 65 × 92 (25¹/₂ × 36¹/₄)
 Collection Henri Samuel
 Photo Galerie Henriette Gomès

67 *Le rêve I*
 (The Dream I)
 1955
 Oil on canvas
 130 × 162 (51 × 63³/₄)
 Private collection
 Photo Jacqueline Hyde

68 *Le rêve II*
 (The Dream II)
 1956–57
 Oil on canvas
 130 × 163 (51 × 64)
 Private collection
 Photo Jacqueline Hyde

69 *Nature morte dans l'atelier*
 (Still-life in the Studio)
 1958
 Oil on canvas
 73 × 60 (28³/₄ × 23¹/₂)
 Private collection
 Photo Jacqueline Hyde

70 *Jeune fille à la fenêtre*
 (Girl at the Window)
 1957
 Oil on canvas
 160 × 162 (63 × 63³/₄)
 Private collection
 Photo Jacqueline Hyde

71 *La ferme à Chassy*
 (The Farm at Chassy)
 1958
 Oil on canvas
 81 × 100 (32 × 39³/₈)
 Private collection
 Photo Jacqueline Hyde

72 *Jeune fille se préparant au bain*
 (Young Girl Preparing for her Bath)
 1958
 Oil on canvas
 162 × 97 (63³/₄ × 38)
 Private collection
 Photo Galerie Henriette Gomès

73 *Grand paysage avec vache*
 (Landscape with a Cow)
 1959–60
 Oil on canvas
 159.5 × 130.4 (62³/₄ × 51¹/₂)

Private collection
 Photo Pierre Matisse Gallery

74 *Le phalène*
 (The Moth)
 1959
 Oil on canvas
 162.5 × 130 (63³/₄ × 51)
 Private collection
 Photo courtesy Electa

75 *Nature morte à la lampe*
 (Still-life with Lamp)
 1958
 Oil on canvas
 162 × 130 (63¹/₂ × 51)
 Musée Cantini, Marseille
 Photo Delleuse, Marseille

76 *La tasse de café*
 (The Cup of Coffee)
 1959–60
 Oil on canvas
 162.5 × 130 (63¹/₂ × 51)
 Private collection
 Photo courtesy Electa

77 *Grand paysage à l'arbre*
 (Large Landscape with Tree)
 1960
 Oil on canvas
 130 × 162 (51 × 63³/₄)
 Musée National d'Art Moderne,
 Centre George Pompidou, Paris
 Photo courtesy Electa

78 *La chambre turque*
 (The Turkish Room)
 1963–66
 Oil on canvas
 180 × 210 (70⁷/₈ × 82⁵/₈)
 Musée National d'Art Moderne,
 Centre Georges Pompidou, Paris

79 Detail of *La chambre turque*

80 *Les joueurs de cartes*
 (Card-players)
 1966–73
 Oil on canvas
 190 × 225 (74³/₄ × 88¹/₂)
 Museum Boymans–van Beuningen,
 Rotterdam

Biographical Notes

Balthus was born Count Balthazar Michel Klossowski de Rola in Paris on 29 February 1908. His father, Erich, was an art historian and painter, as well as a successful stage designer. His mother, Baladine, also an artist, became Rainer Maria Rilke's muse. His older brother Pierre, born in 1905, became a well-known author-philosopher and painter who is still very active today.

In 1922 a book of Balthus's drawings, *Mitsou*, was published with a preface in French by Rilke. Balthus learnt his craft mostly by copying old masters, such as Poussin and Piero della Francesca. His first private show was at the Galerie Pierre in Paris in 1934. His friends included Antonin Artaud, André Derain, Pablo Picasso, Alberto Giacometti and Albert Camus. He married his first wife, Antoinette de Watteville, in 1937.

Balthus was drafted for the war, sent to the front and wounded in 1939. Moving from Paris to Champrovent in the Savoy region of France, he then spent the remaining years of the war in Switzerland, where his sons Stanislas and Thadée were born, in 1942 and 1944. After the war he returned to Paris, and in the early 1950s he moved to the Château de Chassy in the Morvan. In 1961 his friend André Malraux, then General de Gaulle's Minister of Culture, appointed him head of the French Academy in Rome. Balthus accepted the appointment and undertook a complete restoration of Villa Medici, seat of the academy.

In 1963 he accepted an official assignment from Malraux to select classic Japanese works for an exhibition, and in Tokyo he met his future wife, Setsuko Ideta, whom he married in 1967. In 1973 Setsuko, herself a gifted painter, gave birth to a daughter, Harumi. In 1977 he left Rome and settled permanently in his present home in the Swiss Alps, where he still works in his studio on a daily basis.

In 1991 Balthus was awarded the prestigious Praemium Imperiale for painting by the Japan Art Association in Tokyo. His many one-man shows have included retrospectives at the Tate Gallery in London (1968), the Musée National d'Art Moderne, Centre Georges Pompidou in Paris (1983), the Metropolitan Museum in New York (1984), the Musée des Beaux Arts in Lausanne (1993) and the Museo Nacional Centro de Arte Reina Sofía in Madrid (1996).